To Kay Fernandez —

With a fond and warm

welcome to this " Celebration

of flora."

Gladys Haddad

December 2007

Flora Stone Mather

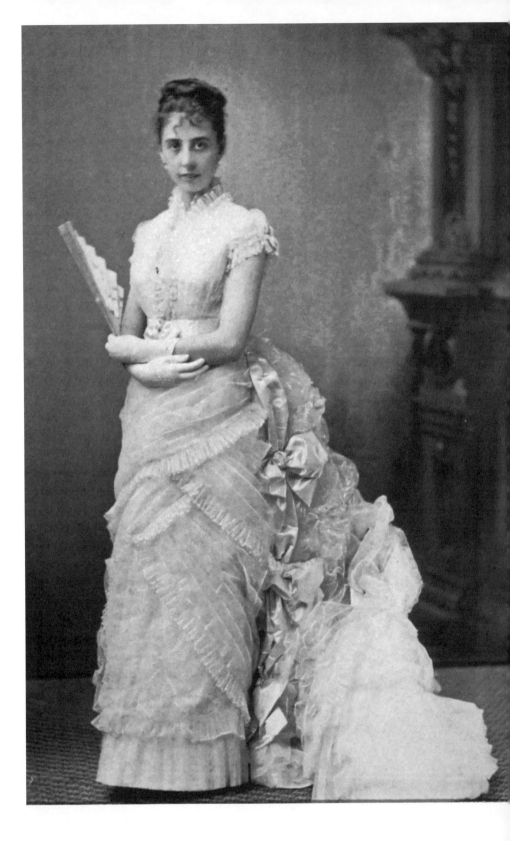

Flora Stone Mather

Daughter of Cleveland's Euclid Avenue

&

Ohio's Western Reserve

GLADYS HADDAD

The Kent State University Press
KENT, OHIO

Frontis: Flora Amelia Stone as a young woman in the years prior to her marriage, ca. 1873. Case Western Reserve University Archives

© 2007 by The Kent State University Press, Kent, Ohio 44242
ALL RIGHTS RESERVED
Library of Congress Catalog Card Number 2007021832
ISBN 978-0-87338-899-3
Manufactured in the United States of America

11 10 09 08 07 5 4 3 2 1

LIBRARY OF CONGRESS CATALOGING-IN-PUBLICATION DATA
Haddad, Gladys.
Flora Stone Mather : daughter of Cleveland's Euclid Avenue and
Ohio's Western Reserve / by Gladys Haddad.
p. cm.
Includes bibliographical references and index.
ISBN-13: 978-0-87338-899-3 (hardcover : alk. paper) ∞
1. Mather, Flora Stone, 1852–1909. 2. Philanthropists—Ohio—Biography.
3. Cleveland (Ohio)—Biography. 4. Ohio—Biography. I. Title.
CT275.M5639H33 2007
361.7'4092—dc22
[B]
2007021832

British Library Cataloging-in-Publication data are available.

Contents

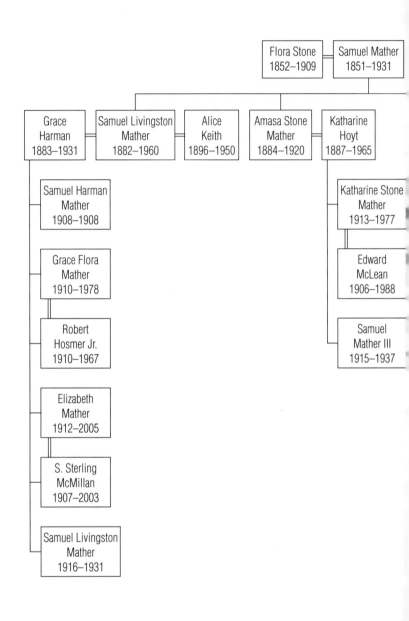

Descendants of Flora Stone & Samuel Mather

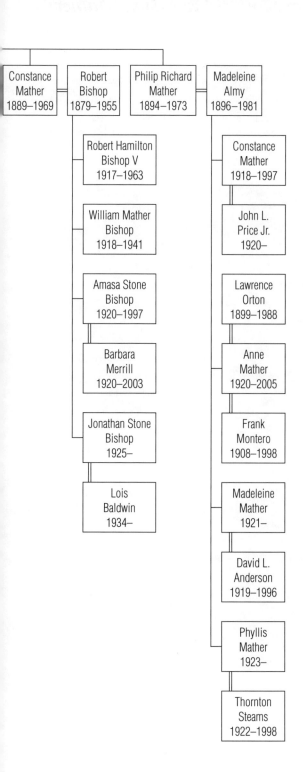

Constance Mather 1889–1969

Robert Bishop 1879–1955

Philip Richard Mather 1894–1973

Madeleine Almy 1896–1981

Robert Hamilton Bishop V 1917–1963

William Mather Bishop 1918–1941

Amasa Stone Bishop 1920–1997

Barbara Merrill 1920–2003

Jonathan Stone Bishop 1925–

Lois Baldwin 1934–

Constance Mather 1918–1997

John L. Price Jr. 1920–

Lawrence Orton 1899–1988

Anne Mather 1920–2005

Frank Montero 1908–1998

Madeleine Mather 1921–

David L. Anderson 1919–1996

Phyllis Mather 1923–

Thornton Steams 1922–1998

Descendants of Samuel Livingston Mather

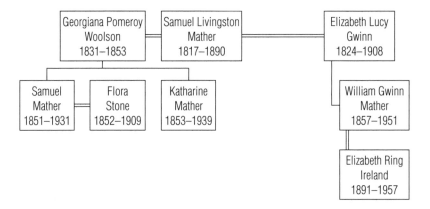

Descendants of Amasa Stone

Preface and Acknowledgments

I feel so strongly that I am one of God's stewards. Large means without effort of mine, have been put into my hands; and I must use them as I know my Heavenly Father would have me, and as my dear earthly father would have me, were he here.
—*Flora Stone Mather*

Flora Stone Mather entered my life through my dissertation, "Social Roles and Advanced Education for Women in Nineteenth Century America: A Study of Three Western Reserve Institutions." The three institutional formats that offered advanced education for women in the nineteenth century were located in northeastern Ohio's Western Reserve: Oberlin College, coeducation; Lake Erie Female Seminary and College, single-sex education; and Western Reserve University's College for Women, a coordinate to the Adelbert College for men. Flora Stone Mather was the benefactor of the College for Women, and in my research I found her to be an inspiring and unusual subject and decided then, in 1980, that I would write her biography.

So began a relationship of involvement and identification between biographer and subject. Historians are schooled to strive for distance in order to preserve objectivity. Yet, there is the need to recognize the subjectivity of biography: the challenge is to reveal one's attachments and detachments even while maintaining a critical, scholarly stance. In this case, Flora Stone Mather's life became particularly personal, for its details emerged through

the numerous letters she wrote and received. After I read them all, I concluded that the narrative of her life should be documented as it had unfolded for me, through her revealing and intimate and wonderful letters.[1]

I was fortunate to find extensive correspondence archives at the Western Reserve Historical Society, where the Samuel Mather Family Papers are housed, and at the Case Western Reserve University Archives, where the history of the College for Women is preserved. My friendship with the descendants of the family of Samuel and Flora Stone Mather, too, brought its special rewards in conversations and sharing of documents.

As my research advanced, I presented several scholarly papers and produced three documentary films on the Mathers in which family members were featured: *Samuel Mather: Vision, Leadership, Generosity* (1994), *Samuel and Flora Stone Mather: Partners in Philanthropy* (1995), and *Flora Stone Mather: A Legacy of Stewardship* (1998).

Entering the life of a prominent family is a privilege and carries a responsibility to respect their privacy. I honored this with a pledge of trust to members of the Mather family. Their witness came with attendance at or review of all papers and film presentations. The rewards of this relationship have been extraordinary.

I dedicate this biography to one family member, the late Madeleine "Molly" McMillan Offutt (1940–1999), great-granddaughter of Samuel and Flora Stone Mather and Flora's twentieth-century counterpart. Molly urged me on my way, saying, "Gladys, you *must* do something about Flora."

I spent my junior year at Flora Stone Mather College and am an alumna of the Flora Stone Mather Alumnae Association. Their generous support for the research and production of this biography and my documentary *Flora Stone Mather: A Legacy of Stewardship* have special meaning for me. I was especially pleased and proud to deliver "A Tribute" at a gathering of the alumnae association.[2] When it was announced at the 2005 Flora Stone Mather Alumnae Meeting and Brunch that both the Women's Center at Case Western Reserve University and a professorship were to be named for Flora Stone Mather, the joyous response was overwhelming! In my comments that followed, I offered that "the naming of the Women's Center and the Professorship *honors* Flora Stone Mather. It is her *spirit* that has inspired the remarkable accomplishments of the Alumnae Association. It is *your* commitment and dedication, *your* faithful advocacy on behalf of women, that Flora is well pleased."

This biography had its advocate in Joanna Hildebrand Craig, Assistant Director and Editor-in-Chief of the Kent State University Press. She recognized "the quiet power" that defined the life of Flora Stone Mather and remained constant in her encouragement of a grateful author whose foremost desire was "to do right by Flora."

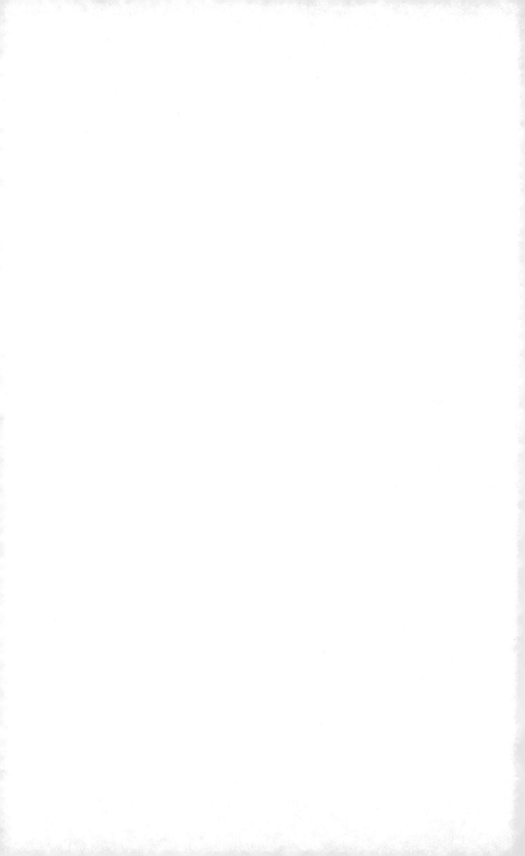

The Singularity of Flora Stone Mather, 1852–1909

A nineteenth-century American female was first a daughter, frequently a sister, traditionally a wife, and then usually a mother. American womanhood, viewed through these constructs, offers the opportunity to examine the life of Flora Stone Mather, daughter of Cleveland's Euclid Avenue and Ohio's Western Reserve.

An ideal of nineteenth-century womanhood and prototype of America's Progressive period, Flora Stone Mather supported nearly every philanthropic cause and was personally active in the fields of religion, education, and social welfare. She inherited her wealth from her father, and since it was money she had not earned, she was committed to spend it as her "Heavenly Father" would have her and her "dear earthly Father" would have her, "were he here."

Flora Stone was the daughter of New England–born entrepreneur Amasa Stone; a student of Mount Holyoke–trained Linda Guilford; a parishioner of the First Presbyterian Church's reverend William Henry Goodrich and pastor-educator Hiram C. Haydn; and the wife of New England distinguished descendant, industrialist-philanthropist Samuel Mather. Within her home, school, church, and marriage Flora Stone Mather acquired those values that supported her advocacy for education and social welfare and profoundly influenced the quality and character of her efforts.

A woman of extraordinary accomplishments, Flora Stone Mather, a model of her time and station, demonstrated firm personal convictions in the implementation of her good works. Modest in demeanor, she refused attention and public recognition. Small in stature and fragile in health, it was the call to service as "one of God's stewards" that fueled her energies. She provided financial resources that led to the creation of organizations, many of which continue to exist today. She sat on the boards of these organizations and formulated policies and practices. She maintained an onsite presence, interacting with the staff and clients. In the twenty-five years before her death at the age of fifty-six from breast cancer, she achieved a remarkable record for philanthropy. Her will listed bequests to thirty educational, religious, and humanitarian efforts in the United States and abroad.

Her father made his fortune in railroads and bridges during the Civil War. He refused to let Adelbert, his only son, serve—seeking to preserve him for a career in civil engineering and finance. Tragically, while a student, Adelbert drowned; this provoked a lifetime of emotional and physical distress for Amasa that, compounded by business-related problems, led eventually to his suicide.

The sisters, Clara and Flora, were devoted to each other, although their paths diverged over the use of monies their father left them. The elder, Clara, married and used her funds to support a lifestyle befitting her husband—journalist, historian, and statesman John Hay. Only when Flora requested her participation with benefactions that paid tribute to their father did she share her wealth.

Flora's marriage to Samuel Mather, a Euclid Avenue neighbor and friend, was a love match. His family's wealth in land, iron ore, and shipping had not been, with the exception of their church, directed toward philanthropic causes. When the couple married they lived with her parents, in whose home philanthropy was a way of life. He was swept up in it, and what emerged was a partnership of exceptional proportions, benefiting Cleveland.

Their deeply affectionate and mutually respectful relationship provided the basis for a loving home for their four children, one in which family life, in a replication of their experiences, was built on inculcating soundly based spiritual, ethical, and intellectual values. The children shared a strong sense of identity and abiding camaraderie. All four understood

the responsibilities of their legacy and sought to honor it in both their personal and public lives.

Flora's teacher Linda Guilford assigned "Daytime Stars" as the subject for her graduation essay. Flora wrote: "They are shining down over our heads with all their splendor reflected from the distant sun, but we do not see them, they are lost in the light of common day. Many bright spirits shine in the heaven of each one of us as we go on our daily round, sometimes unheeding. Their sweet influences soothe and help us. We know they are there, but when the dark closes around us, gem after gem looks out till their effulgence pierces the midnight and it is midnight no more." "We have seen such a one," wrote Linda Guilford, "and we can not forget her."[1]

1818–1851

They did not come to better their position or accumulate wealth:
they came "in obedience to a purely intellectual craving to face
inevitable sufferings for the triumph of an idea."
—*Alexis de Tocqueville,* Democracy in America

For several generations before their births in 1818, the ancestors of Flora's parents, Amasa Stone and Julia Ann Gleason, had been sturdy New England yeomen who bore their strenuous part in establishing a new nation. While these forbears in each generation had been leaders in substance, character, and respectability in their own towns, their individual interests and influences had been confined to narrow lines in their local environments. The two families, the Stones and the Gleasons, were destined to converge and eventually merge in Worcester County in central Massachusetts.

Amasa Stone, of the eighth generation, was born April 27, 1818, son of Amasa and Esther (Boyden) Stone, the ninth of ten children, on a farm in Charlton, Massachusetts, owned and occupied by his father and previously by his grandfather. Amasa labored from early boyhood on the farm and attended the short terms of the local one-room district school. During his childhood, he became greatly interested and proficient in cabinet making and carpentry.

In 1835, at age seventeen, he was apprenticed to his older brother Daniel Stone in the construction trade and moved to Worcester. He progressed rapidly from carpentry into contracting. Employed at $40 per year, he began building houses and churches. In the winter of 1837, he attended

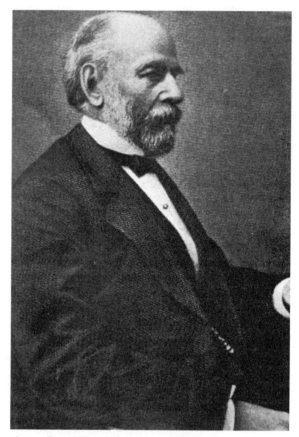

Amasa Stone, Flora's father, was a Massachusetts bridge builder who came to Cleveland and the Western Reserve to build railroads and became a leader in the burgeoning industrial empire. Case Western Reserve University Archives

the academy of Professor Bailey, in Worcester, having saved enough from his small wages to pay a single term's expenses. Possessed of great energy and ambition, within two years he bought out the remaining year of his apprenticeship and became his own master. At twenty he took contracts to build three churches and several other buildings. He joined his two older brothers Daniel and Joseph in a contract for the construction of a church building in East Brookfield, Massachusetts. In 1839, he engaged with his brother-in-law William Howe to act as foreman in the erection of two church edifices and several houses in Warren, Massachusetts.

In 1828, Azuba Towne Stone, Amasa's older sister, had married William

Howe, a talented inventor and bridge engineer. In 1839, Howe completed unique designs for a bridge truss consisting of timber diagonals and vertical iron ties; he was granted patent rights for the structure in the following year. The truss made possible carrying heavy loads over short spans with singular effectiveness and economy. It was eagerly seized upon by the infant New England railroad interests, intent on forcing access to the West through extremely serious topographical barriers. In 1840, Howe enlisted the services of Amasa, who joined his brothers Daniel, Joseph, and Andros in a family enterprise to construct the first commercial "Howe truss."

The Howe truss saw its first practical use in bridging the Connecticut River at Springfield for the Western Railroad Corporation. This company had been formed in 1833 to extend the line built by the Boston and Worcester Railroad across the Berkshire Mountains to Albany. Boston merchants financed the project widely regarded to be a costly fantasy, in the hope of competing with New York in tapping the raw materials and potential markets of the Ohio Valley. In 1840 Howe and Stone secured the contract to build the first railroad bridge over the Connecticut River, a major obstacle to the Western Railroad's route. They achieved its resolution by constructing seven timber spans of 148 feet each. Amasa prepared the bridge footings in the quicksand of the riverbed. The job was reasonably well done; the bridge lasted some thirteen years, at which time it was replaced by another Howe truss.

During the winter of 1841, young Stone, now a seasoned bridge expert, superintended the construction of nearly one thousand feet of Howe trusses through the rough terrain of the Green Mountains for the same railroad. By 1842, he was ready for the next step in his career. Enlisting the financial support of a Springfield businessman, Azariah Boody, Stone purchased from his brother-in-law the patent rights of the Howe truss for the New England states, a transaction amounting to some $40,000.[1]

Amasa Stone was riding the crest of the beginning of a rapid, phenomenal expansion of the United States from a self-sustaining agricultural nation to a great industrial and commercial world power of enormous resources. Endowed with his ancestors' strength and in addition his own ambition and abilities, he took advantage of the opportunities offered in the rising flood of national expansion.

Julia Ann Gleason, of the seventh generation, was born December 21, 1818, in Warren, Massachusetts, the second daughter of John Barnes and Cynthia Hamilton Gleason. Five generations of Gleasons had lived in

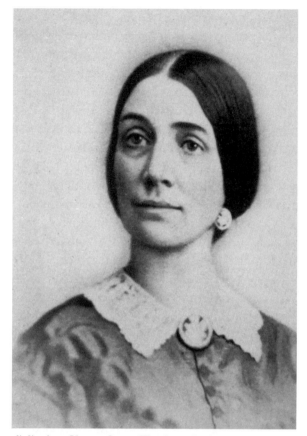

Julia Ann Gleason Stone, Flora's mother, was a Massachusetts seamstress before her marriage to Amasa Stone. Western Reserve Historical Society

Sudbury, in eastern Massachusetts, when the family was drawn to the western part of the state, specifically Warren, John's birthplace. Cynthia Hamilton was from the adjacent town of Brookfield. The pair had three daughters: Huldah Angeline, Julia Ann, and Louisa. When Cynthia died in 1821, Huldah was five; Julia, three; and Louisa, one. The next year, their father married their mother's sister, Susan Hamilton, and within two years he had a fourth daughter, Wealthy. In 1825, John died and left Susan a young widow with four daughters under the age of nine.

In 1835, Liberty Stone married Charlotte Hamilton, Julia Gleason's cousin, daughter of her uncle Seth Hamilton in what was the first of several connections between the Gleason and the Stone families. Liberty Stone

brought his bride to Charlton; he was the only of his father's five sons to continue in the ancestral occupation of farming. His four brothers turned to occupations in business and industry. One of these, Daniel Stone, in 1838 took Julia's older sister, Huldah, as his wife in Warren. They lived in Springfield, where Julia Ann was employed as a seamstress.

A young nineteenth-century American woman could support herself in the vicinity of a hub of textile production afforded by the mills at Worcester. In all probability, the young bridge-builder Amasa Stone, based in Springfield, met his future wife, related by marriage to two of his brothers, within the family circle. Following the example of their siblings, on January 13, 1842, Amasa Stone and Julia Ann Gleason were married in Warren, and then in Springfield they established a simple, frugal New England home.[2]

The partnership forged by Amasa Stone and Azariah Boody lasted five years, until 1847. During this period numerous bridge contracts were successfully accomplished and Stone resolved a serious suspicion that the Howe truss would prove dangerous over protracted periods of use. The latent defect in the original structure was the tendency of the timbers to expand and contract seasonally. Amasa devised innovations involving a combination of longitudinal keys and clamps, plus the use of iron socket bearings.

In later years, Stone related the process by which this innovation was accomplished:

> I came to the conclusion that something must be done or there must be a failure, and it must not be a failure. The night following was a sleepless one, at least until three o'clock in the morning. I thought, and rolled and tumbled, until time and again I was almost exhausted in my inventive thoughts, and in despair when at last an idea came to my mind that relieved me. I perfected it in my mind's eye, and then came to the conclusion that it would not only restore the reputation of the Howe bridge, but would prove to be a better combination of wood and iron for bridges than then existed, and could not and would not in principle be improved upon. Sleep immediately came. I afterwards, with models, proved my conclusions and have not up to this time, changed them.[3]

Stone's improvements to the Howe Bridge considerably advanced him professionally, and while yet a young man he was reputed to be the most eminent builder in New England. In 1845, Amasa Stone assumed the

duties of superintendent of the New Haven, Hartford & Springfield Railroad while continuing his partnership in the firm of Boody, Stone, and Company. Within a year his rapidly expanding construction business required all his time and attention, and he relinquished the post of superintendent. But in 1846 he served the company by an act he later regarded as one of his life's greatest accomplishments.

In autumn that year, the main line bridge over the Connecticut River at Enfield Falls, which was a quarter of a mile long, was carried away by a violent hurricane. The traffic over the New Haven, Hartford & Springfield Railroad at that point was very great, and every hour that could be saved in the reconstruction of the bridge was of great value to the company. The railroad consulted Amasa Stone and contracted him to rebuild the bridge in forty days. He accomplished the remarkable feat, and the board of directors adopted highly complimentary resolutions and awarded Stone $1,000 beyond his contract price.

The following winter, the partnership of Boody, Stone, and Company was dissolved by mutual consent, and the former partners divided the territory that their bridge patent contract covered: Stone took Massachusetts, Connecticut, and Rhode Island, and Boody took Maine, New Hampshire, and Vermont. Soon after, Amasa Stone formed two new associations. One was a partnership with D. L. Harris for building bridges in Massachusetts, Connecticut, and Rhode Island; the other was with Frederick Harbach and Stillman Witt, for construction of a railroad in the West—the Cleveland, Columbus & Cincinnati Railroad. The latter partnership would lead to fame and fortune.

Frederick Harbach of Springfield, Massachusetts, was born to a family of very modest circumstances. Like Amasa Stone, imbued with ambition but without the benefit of formal scientific education, Harbach accumulated his stock of engineering skills experientially. Starting in 1836 as a chainman of the Western Railroad, he rapidly passed to division foreman and in 1843 became resident engineer on the New Haven, Hartford & Springfield Railroad. There he became associated with Amasa Stone and developed great interest in the potential applications of the Howe truss. In 1846, he took out patents on an iron version of this structure and built at least one of thirty feet in length on the Western Railroad near Pittsfield. During 1845–1848, Harbach entered various contracts involving the construction of railroads, roads, and canals. In 1847, he accepted an offer to assist John Childe, veteran railroad builder, in surveying various routes for the proposed Cleveland, Columbus & Cincinnati Railroad.

Stillman Witt of Worcester, Massachusetts, like Stone and Harbach, was self-educated. When he was thirteen, he was hired to run a ferry at Troy, New York. A passenger who sensed his intelligence and promise befriended the young lad. Canvass White, former engineer on the Erie Canal and United States civil engineer in charge of internal improvements in the New York area, received the Witt family's consent to train young Stillman in the engineering profession.

Stillman Witt excelled in the apprenticeship and aided in the construction of bridges, canals, and docks. He was subsequently given charge of the steamboat *James Farley*, the first lake-canal boat to tow goods on the Erie Canal to New York without transshipment. In 1840, Witt became general manager of the Western Railroad Corporation, where he became associated with Frederick Harbach and Amasa Stone.

In 1849, at the conclusion of the survey of proposed routes for the Cleveland, Columbus & Cincinnati Railroad, the three young engineers formed a partnership. With assets of about $125,000, they began constructing a railroad widely considered a venture destined to fail. This was an enterprise of the greatest magnitude, and it reflected equally on the ability and the courage of the contractors, as a great part of the payment made to them was in the capital stock of the company, which was at the time of very doubtful value. But their sagacity equaled their courage, and the stock became extremely valuable as soon as the road was completed: it would award two of the three young men with fortunes and upper-class status within a few short years.

While Amasa Stone advanced his career in the expanding world of business and industry that took him away to sites in other states for long periods of time, in Springfield Julia Gleason Stone maintained her sphere of influence within the home. On July 8, 1844, Adelbert Barnes Stone was born and on December 28, 1849, Clara Louise.

With the completion of the Cleveland, Columbus, and Cincinnati Railroad as far as Columbus, on February 17, 1851, Amasa was offered the position of railroad superintendent. Opportunities in Ohio, where dependence on canals and turnpikes was holding back development, lured him to the new West. An industrial empire was in the making south of the Great Lakes—Cleveland was at its center, and Amasa Stone was to be one of the empire builders. He accepted the offered position and in spring 1851 moved his family to Cleveland and northeastern Ohio's Western Reserve.

1852–1865

The town is clean, tasteful, elegant and healthful; for vegetables, fruit and flowers it is preeminent—for groves, parks, ornamental trees and shrubs, it is hardly surpassed. Her public and private schools are excellent; her medical college superior to any in the West and the prevailing character of her society is educational, moral and religious. It is, therefore, just the spot for the man of moderate income, to live and educate his family.
—*A mid-nineteenth-century visitor to the Forest City; from* Rose, Cleveland: The Making of a City

In April 1851 Amasa and Julia Gleason Stone and their two children—Adelbert, five, and Clara, two—arrived in Cleveland and settled into a home on the corner of Superior and Bond streets (East 6th Street). A typical Victorian house embellished with wrought iron work, it had a fenced-in front yard and an orchard to the rear that extended to Vincent Street. Here on April 6, 1852, Flora Amelia was born.[1]

Both commerce and manufacturing attracted people to the Cleveland area. The excitement generated by the completion of the Cleveland, Columbus & Cincinnati Railroad (CC&C) prompted a boost in population.[2] Along with their labors on the CC&C line, the firm of Harbach, Stone, and Witt was awarded the contract for the construction of another pioneering project, the Cleveland, Painesville & Ashtabula Railroad (CP&A). In 1852, Amasa Stone was a director of both roads, and by 1857 he was the president of the CP&A.[3]

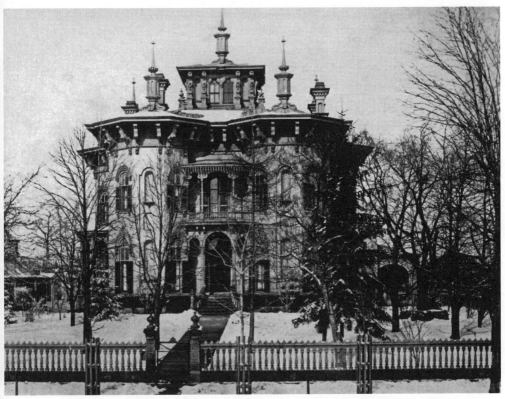

The Amasa Stone Mansion, 514 Euclid Avenue at East 13th Street, 1858. Western Reserve Historical Society

Modest homes in the vicinity of Public Square yielded as business moved eastward from Superior Street. The local upper class had formed a tightly knit society that entertained itself and attempted to control the city's destiny. By 1858, railroad entrepreneur Amasa Stone, with a national reputation at forty, was one of that society and ready and able to establish a Euclid Avenue address.

Located at East 13th Street, on the north side of Euclid Avenue, Amasa Stone's house was a highly complex creation, a monument to his skill and experience as a carpenter, contractor, and bridge builder. Rejecting an American design in favor of the Continental, he created an Italian-style villa reflective of prevalent European tastes. Reportedly, "It represented the state of the art in architectural design from its highly stylized romantic details to its structure system and mechanical devices."

The 8,500-square-foot residence took more than 700,000 bricks to construct. Its twenty-three-inch-thick walls were designed to insulate rooms and stabilize temperatures. The roof was covered with painted tin. The interior was centered on a grand mahogany hallway with an open staircase to the second-floor bedrooms. The family's private parlor, nursery, and a "bathing room" were to one side of the hall, and a public reception room, library, and dining room were on the other. The kitchen and pantry, housed in the rear wing, had piped water and gas. All the main rooms had paneled ceilings and molded cornices, rosewood or oak doors, and fireplace mantels sculpted from Vermont statuary. Amasa's personal library had a fireproof recess that held his desk, bookcase, and safe. The basement furnace, encased in a masonry fortress to inhibit explosions, centrally heated the house. The basement housed the laundry and coal room.[5] There was a wide lawn in front, ending at a stone fence. Behind was a big yard extending north to Chester Street with a stable, coasting hill, garden, fruit trees, and greenhouse.[6]

Within a decade of Amasa Stone's arrival, Cleveland's population had doubled to forty thousand. Stone's mansion was ready for occupancy, and the address "at home on Euclid Avenue" was 514. In the midst of opulence created by Stone's drive for wealth and status, the three children—Adelbert, then sixteen; Clara, twelve; and Flora, eight—were reared "in an atmosphere of simplicity and devotion by a gentle and loving mother" and a father who was both autocratic and indulgent. From their parents the children received an introduction to the study of biblical literature, which was further nurtured at church.[7]

Flora Amelia Stone grew up under the influence of parents whose strengths became her defining characteristics: her father's clear judicial type of mind and her mother's delicate but firm, sympathetic but conscientious womanliness. From her earliest years, Flora Stone was described as "a frail child, whose lack of strength was offset by an abundant enthusiasm, coupled with a fine mind and good judgment." At Linda Guilford's Cleveland Academy, from which she graduated with honors, she had many friends who often urged, "Wait until Flora comes. She will know just how to go ahead."[8]

Amasa and Julia Stone were parishioners of the First Presbyterian Old Stone Church on Cleveland's Public Square. Here, Reverend William Henry Goodrich, who came as pastor in 1858 and remained until his death

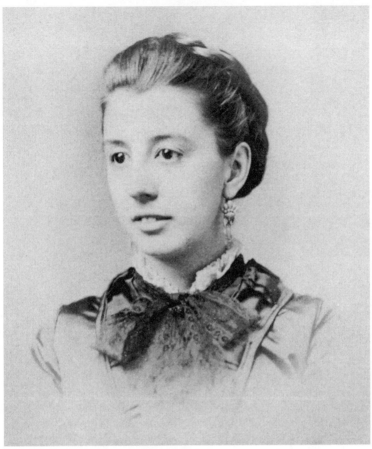

Flora Amelia Stone, born in Cleveland and the youngest of the three children of Amasa and Julia Gleason Stone, was a schoolgirl at the Cleveland Academy, ca. 1865. Western Reserve Historical Society

in 1874, strongly influenced the children. Goodrich was a graduate of Yale's theological department, where his father was a distinguished professor; his mother was a daughter of lexicographer Noah Webster. As a youth, Goodrich pursued literary interests, which contributed to the development of a liberal outlook and temperament for one trained in high Calvinistic doctrine. In the exercise of his office, he advised rather than dictated, encouraged rather than forced. It was said that "he brought light into every circle, and added vigor to every scheme; yet with such grace, modesty and sanctified common-sense were his opinions presented and his acts distinguished."[9]

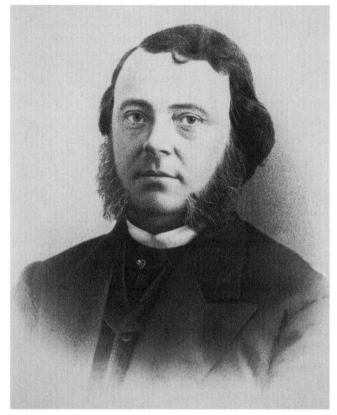

*The Reverend William Henry Goodrich, pastor at Cleveland's Old
Stone Church, where the Stone family worshiped. Western Reserve
Historical Society*

In 1860, as residents of Cleveland's Ward 5, the Stone children could
attend the East St. Clair Street School in their neighborhood. Flora could
enter the secondary and intermediate school. Adelbert and Clara were
eligible for high school or the nearby Cleveland Academy located at
"the Flatiron," the point between Prospect and Huron streets. Amasa,
a board member of the Cleveland Academy, ensured that Adelbert and
Clara were enrolled there. T. G. Valpy was the principal and Miss Linda
Guilford was assistant principal.[10]

Linda Thayer Guilford's career as a teacher began in 1848, the year
following her Mount Holyoke commencement, when, fresh from the mis-
sionary zeal of its principal Mary Lyon, she arrived in Cleveland. Over
the next seventeen years, Guilford was associated with several Cleveland

schools, and her reputation grew. Regardless of the school's official name, it was known as "Miss Guilford's," after its foremost teacher.[11]

After a fourteen-month hiatus from teaching in which she traveled abroad, Linda Guilford decided to open a day school in the original building described as "the academy at the point," which had been abandoned in her absence. On November 21, 1861, in the renovated and fresh schoolroom, there gathered eighteen pupils, a number that soon increased to twenty-eight. Among them were the Stone sisters, Clara and Flora.

The life of this school coincided with the period of the Civil War: "The little world within those walls, like that outside, was swayed into joy or grief with each day's bulletins. Even children sprang into maturity before those terrible realities," wrote Linda Guilford.

> Morning and afternoon telegraphic despatches were discussed in the class-room and during the general hour of talk. Experience soon taught us we must wait for the truth, which might be more startling than the wildest rumors. Every department of social life was whirled into activity; fortunes were being made and lavishly expended; new names were on all men's lips while kinsmen and brother were hid in the smoke of battle or lying in far-off hospitals. Regiments coming and going, with the sound of martial music, would never let us forget that the war-tempest was raging, though we saw it not.[12]

Adelbert Stone was the center of the universe for his father; Amasa was grooming him for induction into the world of civil engineering and high finance. Described as modest and unassuming, Dell, as he was called, was personable and friendly. A diligent student, he enjoyed the balance of social activities and athletics. He was at the same time an independent thinker and a dutiful son. He was educated at local academies until 1862, when he turned eighteen and went to join the Reverend Henry M. Colton's Family School for Boys at Middletown, Connecticut. There he prepared for admission to Yale College in the scientific department of the School of Philosophy and Arts.

When the Civil War erupted, Amasa Stone escorted Adelbert to Reverend Colton's School, where he was required to secure a document issued by the U.S. Marshal's Office of the Northern District of Ohio. It authorized Amasa Stone to travel from Cleveland to Middletown, Connecticut, with the assurance "that his said intended journey is legitimate

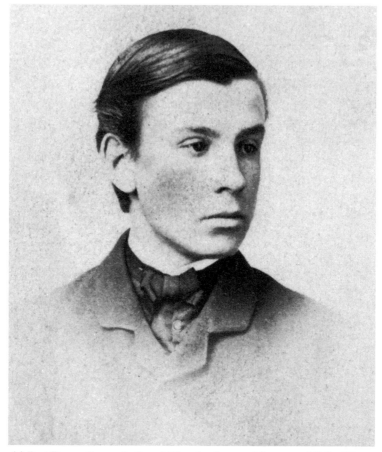

Adelbert Barnes Stone, the first child and only son of Amasa and Julia Glea-son Stone, as a student at Yale College, ca. 1865. Case Western Reserve University Archives

and necessary, and with no purpose to avoid being drafted into military service of the United States."[13]

Adelbert developed strong radical Republican sentiments and yearned to enlist in the Union army. His father fiercely resisted the proposal and the next year, in 1863, an obedient Adelbert went to Yale.[14]

On November 1, 1863, Adelbert answered a letter from Flora, age eleven:

Ma chere soeur [my dear sister],

I received your little letter of the 24th instant in due time and now shall attempt to answer it. I also received Clara's letter of the

23rd. I am glad to hear that you are all well. You want to know if I was tossed in a blanket. I was not but I saw the Freshmen tossed in a blanket, put in a coffin, buried etc. But I not being Fresh was not liable to initiation. The other evening some Sophs took a Fresh by force about two miles out of town and having stripped him they blacked him all over with burnt blacking and then left him to find his way home. How would you like to have them do that to me? But there is no fear of that for they will not touch me. How does the front room look after having been painted? Did you gather many grapes this year? Is the pony getting along all right? Give my love to Father, Mother and Clara. Hoping this may find you all as well as I am

I remain votre frère [your brother], Dell

In January 1865, Adelbert wrote to Flora in French to gain practice for his language studies: "[translated] I have received your letter of the 28th and it is with great pleasure that I take my pen in my hand to respond. We have very bad weather today, snowing, raining and as a result I am staying indoors. We have very good skating here and I went skating the day before yesterday in the evening and I enjoyed myself very much. I bought a new pair of skates. Do you understand what I have written?" Returning to English, he inquired: "Does your music box continue to play as nicely as ever? I wish I had one here for I think it would be very pleasant to have one in my room to play for me while I am studying. I have got your picture and Clara's hung up right over father and mother and it is quite an improvement."[15]

By 1865, the Stone family was securely placed in an elegant world of social and economic ascendancy. Amasa Stone had built an empire around railroads and broadened his interests to score successfully with banking telegraph lines and heavy industry. Stone's wealth grew as he took part of his pay in stock at a time when railroads were booming. He put some of his wealth into the rising steel industry and was a major stockholder in the Cleveland Rolling Mill and several related mills throughout the country. He was also a stockholder and director of several local banks that financed railroad, oil, and steel ventures.[16]

The Civil War helped make him a millionaire. Stone, a staunch Republican, favored the nomination of Abraham Lincoln in 1860 and supported the Union cause in several ways, although he didn't favor the participation of his son. Lincoln enlisted his services for problems dealing with

military supply and transportation. One of Flora's cherished childhood recollections was Lincoln's visit to Cleveland on the way to his inauguration in Washington. She presented him with a small bouquet of flowers and received a kiss from him in return.[17]

Adelbert's schoolmaster, Henry M. Colton, described him as "filial" and wrote of Adelbert's declaration of his intention to meet future expectations "when I shall aid father and do something worth the while." He was at the same time imbued with the soul of an ardent patriot: "He often said that he must go to the war. . . . The Western energy and fire glowed in him. . . . He would have willingly laid down his life for brethren and the government. . . . When men were pouring in from the vast and fertile plains of his own State, he could scarcely restrain his impatience; and we all felt it was more than boyish enthusiasm of a merely martial impulse. It was an intelligent love of country."[18]

Stone's attitude in refusing permission for his son to join the Union army was in keeping with other capitalists of the era.[19] To make up for this, he was active in resolving the manpower problem by financial means. In order to spare Cuyahoga County the "humiliation of a draft," Stone recommended on August 15, 1862, that a committee of thirteen procure $60,000 to be disbursed in securing the necessary quota of recruits for the county.

Joyous celebrations marked the end of the war and the surrender of Lee to Grant at Appomattox Court House, Virginia, on April 9, 1865, when "all the city, a few days afterward" was "standing in awed silence on the wide Avenue, draped in mourning, as down it a band marched before the funeral car that held the murdered Lincoln."[20]

In a letter from Yale dated June 25, 1865, Adelbert wrote to his father: "Tomorrow Profs. Dana and Brush are going to take about 20 of us up to Middletown and vicinity on a mineralogical expedition. We will start early tomorrow morning and be gone two days and expect to have a pleasant time."[21] Two days later on June 27, Amasa Stone received a telegram from Yale College Professor George J. Bush at Middletown: "Your Son Adelbert was drowned while bathing in the Connecticut at Haddam today while on a geological excursion with his class." On June 28, another telegram arrived from Professor Bush at New Haven: "Your son was swimming alone at some distance from his comrades, and was probably taken with cramps, as he threw up his hands and uttered a cry for help. He sank several minutes before any swimmer could reach the spot. And

did not once rise. Up to one o'clock this afternoon the body had not been recovered although every effort was being made."[22]

Lee surrendered to Grant at Appomattox on April 9, 1865, ending the Civil War, which Dell was forbidden to join. On July 8, 1865, Dell would have celebrated his twenty-first birthday. Instead, on Sunday afternoon July 2, 1865, the funeral services were held "at home on Euclid Avenue." The burial took place at Lake View Cemetery.[23] Reverend William H. Goodrich officiated and recalled: "As his pastor, I have known and observed him since he was about thirteen years old. He was singularly true. At home and abroad, his word was taken for fact, and no one was ever deceived in him. His filial confidence has been peculiarly beautiful, and forms one of the sweetest recollections of him in the household. He never felt the command-ment of his father to be irksome, or forsook the law of his mother."[24]

The first tragedy of family life dealt the parents a crushing blow, one from which Amasa Stone would never recover. Clara was sixteen and Flora thirteen. An opportunity beckoned that would allow Amasa Stone to bury his grief and direct his considerable energies. That summer, Amasa Stone built a school for his daughters. Fifteen years later he would build Adelbert College as a memorial to his son.

1865–1871

We can all cheerfully admit Euclid Street is a justly celebrated thoroughfare.
—*Artemus Ward*, Cleveland Plain Dealer

Early in the summer of 1865, a number of Cleveland's businessmen whose children had studied previously at the school known as the "academy at the point" turned their time, talent, and treasure to developing plans for a new educational institution. They were men whose financial fortunes had risen with the Civil War. They interrupted their escalating and sprawling business enterprises to concern themselves with an educational plan that bore the marks of their experiences; they founded the Cleveland Academy.

Amasa Stone had proposed the plan of action: he would supervise the erection of the two-storied brick building that would belong to the stockholders. Stone and his colleagues formed a stock company—with thirty-one subscribers who gave from $100 to $1,000 for a total of $17,400—to purchase a lot and erect and furnish a building. The company rented the premises for five years to Linda Thayer Guilford on the condition that she would pay the stockholders one-fifth of the gross income of the school.[1]

In August 1865, Amasa Stone, who at the time was superintending the erection of Cleveland's Union Depot, acted as the building committee of one and overseer for construction of the school. On January 29, 1866, principal and head teacher Linda Guilford opened the Cleveland Academy in the finished building on the south side of Huron Road, directly across from the Euclid Avenue residence of the Amasa Stone family. She described it:

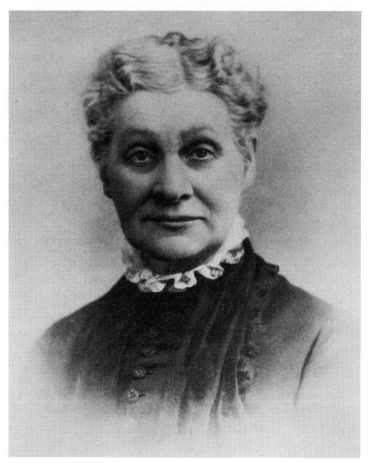

Linda Thayer Guilford, Mount Holyoke graduate, principal, and head teacher of the Cleveland Academy, ca. 1896. Case Western Reserve University Archives

"A solid parallelogram, with regularly placed windows, it was relieved from positive ugliness by a large two-story portico which covered most of the front. The rear was left a plain wall, save a door for exit, from which some wooden steps over the basement entrance descended to the yard. . . . Stone steps led to the front portico at each end. Through the first story a wide hall ran from front to rear, with three rooms on each side; flights of opposite stairs at the end leading to the one upper school-room."[2]

Ninety pupils came for instruction in a classroom outfitted with 120 fixed desks and seats, a number of long settees, and a teacher's table. Although eleven boys enrolled in the first year, the school was designed

for girls. The subjects that Guilford stressed and required examination in were arithmetic, geography, and history. Very few girls of fifteen, the entrance age, could pass them, and those who failed enrolled in the preparatory department and a course of study that included reading, spelling, mental and practical arithmetic, geography, and U.S. history.

Linda Guilford had been taught by Mary Lyon to gather information by topics and distill the content in written abstracts, methods that she applied in her school. She stressed speaking by calling for reports on sermons delivered from various pulpits on previous Sundays; lessons received oral review. Guilford, a person of literary interests, encouraged original work and insisted that each student keep in touch with world events and then speak and write on them.[3]

Accomplishment in oral and written expression was highly prized. It was customary to read the names of the best scholars in each class at the close of the annual public examinations. In the literary exercises of June 1866, Flora Stone recited in an impressive manner "The Death of Paul Dombey." A sweet musical strain accompanied her words. Clara L. Stone recited extracts from the Bible illustrating Faith, Hope, and Charity.[4]

Flora was fifteen in 1867 and a sophomore at the Cleveland Academy, and Clara was a senior. There, taught by Linda Guilford, they received the equivalent of a high school college preparatory course. With the assistance of a vice principal–teacher and a staff of eight teachers, students attended three terms, fall, winter, and summer, commencing on September 9 and, with vacation interludes, concluding on July 1. Flora's curriculum included algebra, botany, history of Greece and Rome, modern history, English analysis, Caesar, and Nepos. Clara prepared for graduation with a course of study that included astronomy, moral philosophy, Butler's analogy, mental philosophy, English literature, primary reviews, and Virgil. "A thorough and systematic study of the bible is a part of the entire course. Composition, Declamation, and writing Abstracts, are constant general exercises," specified the school's *Annual Circular* for 1867–68. The study of Latin, French, and German were encouraged. Tuition for all the English branches and Latin was $20 for fall and winter terms and $13 for summer term; French and German cost $13 each for fall and winter terms and $7 for summer term.[5]

In 1868, the Stone sisters' attendance at the Cleveland Academy was interrupted by a fourteen-month (June 24, 1868–August 9, 1869) family trip to Europe, a respite for the physically and emotionally ailing Amasa

Stone. He had been injured in a carriage accident crossing Public Square, was exhausted by his wartime efforts, and was distraught over the loss of his beloved son, Adelbert.

In October 1868, Flora directed a letter from Berlin to her teacher, "My Dear Miss Guilford":

Far from receiving contrary orders, you are earnestly requested to write me a letter as nice as Clara's. Why it was a great deal better than any of the girls' letters. I haven't had many though. Nettie [Chisholm] is the only one who has not forgotten me. I have written to several others but have received no answers. Nettie tells me she has attained to the dignity of a waterfall & a seat in the last row. Also that Fanny Adams has my seat, really hope she will uphold its honor.

You don't know how Mother has improved, she has not grown fleshy but her face has lost its sallow look & she enjoys everything so much, is really quite the jolly member of the party. As for me I'm growing fat &—ignorant. I thought I knew a little of something before I left home but I find it's a mistake—don't know anything. I'm so fat, Clara sits and makes faces at me & says she thinks my cheeks are swollen. Why I really had to loosen my clothes after dinner. Do you remember when you went into the palace at Berlin that all the men wore those great felt shoes? Isn't [it] funny. I suppose Clara has written all that's worth writing about.

Your Loving pupil Flora (Used to be and going to be again[.)]

O Miss Guilford, Please, what is the name of that little place south of Berlin you spent the winter.[6]

People of a certain station made the grand tour for a variety of reasons, including restorative ones; this was the first trip abroad for the Stone family. Julia Gleason Stone kept a diary while on this European junket. Her brief, dated penciled entries, quoted here, are those of an unlettered woman; twenty-five years of marriage to Amasa Stone had catapulted her into a life far different from that of the western Massachusetts community where she had only the rudiments of an education and supported herself as a seamstress.

Embarking on June 24, 1868, from New York in "fine weather," a ten-day journey took the Stones to Liverpool. Family members and friends

joined them at various locations throughout their stay in England and on the continent. The family spent the month of July in London, where they passed their days seeing the sights—Westminster Abbey, St. Paul's Church, the House of Parliament, London Tower, Hampton Court and Gardens, Hyde Park, Buckingham Palace, St. James Palace, and Marlborough House.

On July 31, the family left for Paris, where they caught up with the Reverend William Henry Goodrich party and with them visited the Hotel Des Invalides "to see the Napoleon old soldiers" and attend church. Before the Stones followed the Goodrich group to Brussels, they went "sight seeing and looking in shop windows, . . . to the dressmaker [and] reordered a dress for Flora." They toured the Louvre, the Palais Royale, and Versailles (where they went through the "galleries of paintings and statuary").

On August 12, Julia noted an event Flora would later fully describe in a composition at the Cleveland Academy: "In the afternoon left in cars for Coblentz the King of Prussia arrived the same evening and the next morning had a review, we had an early breakfast and drove out to see it and was so fortunate as to stand quite near the King as he reviewed ten thousand men also had a bow from the Queen as she sat in her carriage."

Early in October the Stones were in Dresden and for two weeks followed the tourist's route throughout Germany, visiting palaces, galleries, churches, and a synagogue and—to satisfy Amasa Stone's interests—various manufacturing plants.

Foregoing sightseeing during a week of inclement weather in Paris, the Stone women were "running first to a dressmaker and then a milliner . . . to order dresses for Clara and Flora." However, rainy weather not withstanding, the devout family was regular in their attendance at Sunday services. For the remainder of the month, they traveled south through France until, "passing through the heart of the Pyrenees mountains," they reached Berga, Spain.

Circling the country they saw Seville, Cordoba, and Barcelona, which Julia found "a very pretty place," and observed Christmas Eve in nearby Gerona. On Christmas Day the family crossed back into France; they reached Marseilles the next day. December 28 was Clara's birthday. "She received a beautiful boquet in the morning before she had left her room and during the day a shell Portmoa [a purse], a sandal wood fan and a box of fruit in the morning we walked and looked in at the shops in the afternoon took a drive."

The Stones closed the year in Nice, France, and welcomed 1869, according to Julia, on a "lovely day" in which they found "a boquet of violets at each of our plates at breakfast table." Then "we all go to Mrs. Kingsleys room to receive our presents," take a drive, and return, for "the Kingsleys dine with us in our room at 7 pm."

Julia engaged a French teacher and on January 2 wrote "Clara and Flora take their first french lesson." The family remained in Nice for the month of January and in February resumed their travels in Italy. Settled in Florence for a time, the Stones drew upon its artistic treasures, visiting the Pitti picture gallery and the house of Michelangelo. While here, as in almost every place they visited on their grand tour, the Stones encountered friends from home, with whom they exchanged visits. One of these calls was to a tea given by a Mrs. Ball to meet the American ambassador to Italy, Mr. Marsh.

Their next destination was Rome, with stops at the Pantheon, St. Peter's, art galleries, and one or two shops, to "purchase some roman pearls, some roman scarfs." March 24 through 26, Julia "went to Mr. Healy and sat for a Portrait." On March 29, "Mr. Stone sat at Healy for portrait," and Julia was back for a sitting on the 30th.

On April 13, the family left for Vienna, where they joined friends for visits to churches, galleries, and palaces and passed their days with carriage drives, shopping, and concerts. After a week, they moved on to Salzburg for a day, then on to Munich, where, on the morning of April 24, they "went to the palace where three young men were made Knights[,] saw the King in full dress and the procession as they passed in and out of the palace[,] also saw the banquet room and the tables prepared for the lunch."

On April 27, Julia noted, "Mr. Stone's birthday[.] Weather fine[.] Visit the modern picture gallery in the morning and a country palace in the afternoon." At Nuremberg by the end of April, a daily routine was established of going "to the spring in the morning and walk until breakfast then a long walk[,] dine at one[,] then walk again." Early in May "Flora takes her first lesson in German after breakfast."

At the end of May, the family embarked again for Paris, this time for a month's stay, during which they received many callers and "went shopping as usual." Now experienced tourists, they escorted friends to Fontainebleau, to the tombs of Napoleon and Josephine. On June 30, they left for London, a journey of which Julia writes: "the channel very rough" and the weather "very cold and foggy." One day they took in a carriage

with a guide for a "drive to the Bodlean Library, Christ Church College, the New College Chapel, the College of Mary Magdalene" and found "the grounds very extensive and pleasant."

On July 22, the Stones "take the cars" to Liverpool; they were preparing for their return home. "At ten oclock we take the tug for the Steamer at eleven." The trip took ten days and was rough. Julia complained of headaches, ate very little, and, except for occasional visits to the deck, remained in her berth all day. On Sunday, August 1, it was "very pleasant to have services in the Salon in the morn. Dr. Barnes officiates." The next day "the sea is like a mirror all day . . . see a great number of sharks and porpoises . . . pass Nantucket." On August 3 they passed Fire Island and Julia writes, "soon we see land." The tug arrived to guide them into the New York harbor; they passed through customs and reached "the hotel about four PM [to] find Mr. Garretson, Mr. Marbury and Bella [Isabella Stone Marbury, daughter of Andros and Amelia Boomer Stone]."

On August 5, the family took the train for Philadelphia, where they visited Julia's sister Huldah (whose husband, Daniel Stone, had died in 1863) and her children, Augustine and Emma. On August 7, the Stones returned to New York and two days later took a steamer for Albany and from there took a train to Saratoga, their grand tour completed.[7]

Upon their return to Cleveland and the exercise of advantage associated with the grand tour, the Stones resumed their lives on Euclid Avenue among fellow inhabitants of the "linear neighborhood." An address on Euclid Avenue, one of the finest residential streets in America, designated the city's business and cultural leadership. The homes were their monuments, reflective of a way of life that bound and integrated the avenue's residents through ties of family, church, social life, and school.

Flora returned to Miss Guilford's Cleveland Academy accompanied by her cousin Emma Stone; Emma had become a part of the family following the death of her widowed mother, on August 21, 1869, shortly after the Stone family saw her in Philadelphia when they returned from abroad. Flora, who had been away for one entire academic year, was a junior in the 1869 academic year.

In contrast to her mother, who penned sketchy travel-journal entries, Flora, for the next two years, wrote school compositions based on the family's European experiences. While her keen observation and facile writing skills combined to offer sensitive, albeit somewhat romanticized

recollections, they were at the same time informative, insightful, and delightful in their humor.

A Day in "Merrie England"

We clambered to the top of the coach & rolled away, down by the shore of the lovely Lake Windermere, surrounded by blue mountains that threw great shadows on the bright water, ever so many little boats were gliding over it & brightfaced English children in broad hats played on the shore. Then we plunged into the lanes, O the beauty of an English lane, bordered with hawthorne hedges & tall trees, with ivy covered trunks, that meet overhead & cast dancing shadows on the smooth white roadway. Occasionally we passed an English cottage covered with ivy & roses, or a lodge at the entrance of some old park through whose trees we caught sight of the stately hall. Again, we rode under the mountains covered with purple heather or by a field where the cows & sheep looked up from their buttercups & daisies to watch the coach go by. . . . In the afternoon we passed Lake Graemore on whose shore grew the nodding reeds. We overtook a party of English excursionists. Three young ladies rode in a little phaeton drawn by a stout Scotch pony, two more were riding ahead on horseback, while several ladies & gentlemen were walking. All the gentlemen wore regular walking costumes & all the ladies wore wide hats & dark serge dresses. When a Scotch mist (a respectable rain in this country) came up they put on their waterproofs & went on as merrily as ever. To make the picture complete they must have had their sketch books stowed away somewhere to be pulled out at the first stopping place. An English woman is not a regular Englishwoman without her sketchbook.

[August 27, 1869]

In marked contrast to her mother's travel-journal jottings, Flora's school compositions at age eighteen reveal a keen observer whose vivid recollections carry the reader to a specific place and time. Personalities are skillfully drawn, and descriptive passages, offered at times through a romantic lens, have a certain charm.

Koenig Wilhelm der Dritte [King William the Third]

In these days when every one's thoughts are full of the wonderful war

going on between two of the greatest nations in the world [Franco-Prussian War, July 19, 1870–May 10, 1871], it may interest you to hear what I saw of the king of one of these nations, which was little enough to be sure. When we were in Coblentz we heard there was to be a grand military review at which the king was to be present, so early one summer morning we set out from our hotel, leaving the Rhine, with its proud castle of Shrenboutstein, sparkling in the sun. Drove through the quaint streets of the little German town & out into the fresh country, climbed the green hills & reached a great plain at the top. Early as it was, the king had arrived before us & the review had begun. After having watched the evolutions at a distance & having received a gracious bow from the Queen, we left the carriage & small boy fashion, ran to see the show.

Piloted by our eager courier who is an ardent admirer of King William, we soon found places close beside him. He is a grand, old man, the very embodiment of kingly dignity. He was rather stout though appearing less so on account of his height, his slightly florid face was surrounded at the sides with close, almost white whiskers & underneath his heavy eyebrows shone out his keen bright eyes; he rode his horse with all possible grace & ease & his whole bearing was that of a thorough soldier. As the army passed before him & as each soldier's face was turned towards him there seemed to be the feeling that the eye of the general as well as that of the king was upon them.

[October 15, 1870]

The Stone family's European travels, which took them to many museums, developed Flora's interest in art as she became well informed about various collections. Personal qualities of tenderness and compassion that defined her were clearly evident in her response to a fragment of statuary.

Naples

There are so many things to enjoy in Naples. To visit the sculpture gallery of the museum there are very many celebrated things. The thing I admired most was a fragment of a Psyche, only the bust & face remaining. Even the top & back of the head are wanting. It doesn't seem as though a mortal man could create anything so beautiful. It does not seem like marble, it seems like life. It touches one's heart so, there is nothing sad in the face & yet it gives me such

a feeling as though one could not leave it but must take it & comfort it, nothing ever affected me as that did.

[February 26,1870]

Flora also affords the reader a rare glimpse of her father. No other accounts of Amasa Stone credit him with a sense of humor. This encounter as recorded through his daughter's eyes and heart is a warm and unique testimony:

Loch Achray

Scotland

Father was enjoying a seat under a great tree "Ah," said he, "this is just my idea of Scotland & now if we could only hear a bagpipe the whole thing would be complete." As if in answer to this remark a man soon appeared in full Scotch costume (which of course was only put on for the occasion since the clannish dress is entirely done away with) carrying a bagpipe upon which he discoursed "Blue bells of Scotland" & other national airs. If you could have seen him as he strutted—no, not exactly strutted but walked with a most peculiar lordly indescribable air, up & down, you would have laughed as heartily as we, & then the music. We supposed that a real Scotch bagpipe was an entirely different thing from those which we occasionally hear in the street at home but it was about the same. Father soon was perfectly satisfied to have the musician depart, concluding that, since he was not a Scotchman he could not feel much enthusiasm at hearing the music of that country.

[November 12, 1870][8]

The Academy's *Annual Circular* for 1870–71 listed Flora A. Stone as a graduate, along with her friends Nettie S. Chisholm, Mary P. Goodrich, and Jessie P. Taintor.[9] A newspaper account, condensed here, reported the traditional June commencement exercises for 1871 at "Miss Guilford's Female Seminary":

Yesterday afternoon at half-past two, the graduating exercises at Miss Guilford's school were held. The room, which is a large, commodious one, was beautifully decorated with wreaths and flowers. . . . [A]bove [the stage] were the words . . . *Alere Flamann* and the exercises

throughout showed that the injunction to "Nourish the Spark" of education had been faithfully carried out by Miss Guilford.

The pupils of the school, . . . and a very select company of friends, filled the room. . . . Miss Guilford first read the record of the examinations and work of each pupil, which showed excellent progress on their part. Then there was a rustle among the audience as the four ladies who constitute the graduating class came upon the scene and took their places upon a set at front of the stage. They were all tastefully and neatly dressed in white, with white kid gloves and slippers.

The first essay was presented by Miss Nettie Chisholm, on the subject, "We All Wear Clothes." . . .

The next essay was from Miss Jessie Taintor; her subject, "A Word." . . .

Miss Mary P. Goodrich then gave her views of "Perversities." . . .

"Daytime Stars" was the subject of Miss Flora A. Stone's essay, the last of the afternoon. The astronomer who watches the stars by night knows that they exist also when daylight deprives them of their lustre; but the little child thinks that nothing exists in the heavens by day but the sun. Thus the ancients, in their devotion to monarchs and princes saw not the really greater and mightier minds of their poets and philosophers, and the true merit of Shakespeare, Milton, Dante and other master minds were left for us to discern.

. . . After the essay[s], a trio was sung by the Misses Barron, Ellis Smith and Emma Stone, which was followed by a few short, pointed and appropriate remarks by the Rev. Dr. Eells. A piano solo was then rendered by Miss Minnie Remington, when the diplomas were presented by the Rev. Dr. Eels. A presentation of a wreath of flowers to each of the graduating ladies by Miss Guilford, with the hope that they might always make others in the world so happy as they had her during their connection with the school, was followed by a song from six of the pupils, after which a benediction pronounced by the Rev. Dr. Goodrich closed the exercises.[10]

In early July, Amasa Stone wrote "Miss Guilford Madam":

Your esteemed favor of the 29th June came duly to hand.

It gives me much gratification to know that my efforts to sustain you and your school are appreciated.

If I had failed to accomplish something in that direction it is in consequence of incapacity to do so.

I should not however be credited with unselfishness in the matter, as I acknowledge to have been the recipient of great advantages from the institution, saying nothing of the high respect in which I hold yourself and associate teachers. I am gratified to know you appreciate our Flora as we do.

Hoping that our relations in the future may be as agreeable as in the past, I Remain

Sincerely & Truly Yours

Stone Jr.[11]

Amasa Stone fulfilled his commitment to the education of his daughters and provided opportunities for others through his investment and involvement at the Cleveland Academy. Fate intervened and prevented the realization of the same hope and plan he had for the advanced education of his son. He would prevail, however, and establish an institution of higher education in Cleveland to honor Adelbert and preserve his memory.

1871–1873

"The strength of a native place . . ."
—*Walter Havighurst,* The Quiet Shore

Flora Stone was raised in an atmosphere of religious teachings—within her home, school, and church. Next to her family, Flora owed the most to Linda Guilford, the teacher who "expected her girls . . . to be foremost in every good word and work, the pride of the community, the exemplars of the noblest type of womanhood," and to Dr. William H. Goodrich, the pastor during her formative years at the Old Stone Church.[1]

At the Cleveland Academy Flora received her only formal schooling, the equivalent of a high school college preparatory course. Religion was integral to the curriculum; the Bible was used as a textbook, with direct instruction and examinations on its contents. Pupils were inculcated with the value of education, a sense of responsibility for the poor, and a missionary spirit. The Young Ladies Temperance League exemplified the Guilford philosophy, and Flora was an eager recruit.

Flora's interest in missions, the church, and work for social betterment was growing. And she was joined by her friends of the Young Ladies Temperance League, founded by teacher Linda Guilford, which originally required its members to sign pledges promising to personally abstain from liquor and to discourage its use among family and friends. The group soon expanded its emphasis from temperance to promoting

the general welfare of women and children, assisting young women to find jobs and lodgings. They established reading rooms and provided literature that espoused Christian ideals. They started a day nursery program for working mothers and their children, which for five cents a day gave children food, clothing, and medical attention.

Flora reported: "I rushed over to the League and had such a sweet time at the Nursery. The nurse went to her tea and left me alone with the babies. I sat by the fire rocking a cradle and singing to a tired little boy. Then the mothers came for their children and I had a little talk with each one. We want to have them feel that we take an interest in them and their children, for one object is to do them all the good we can."[2]

The Stone children were raised in a spirit of deep but tolerant religion, at home and at the Old Stone Church. In 1868, the Reverend Dr. William Goodrich called together the young women of Old Stone and talked to them about the growing necessity of Christian labor and the part they might take in it. The enthusiastic response resulted in the formation of the Young Ladies Mission Society. Naturally, Clara and Flora joined the new group, and Flora became an especially enthusiastic member. The members decided to turn their efforts toward the community and the satellite mission of Old Stone, located at Superior and 46th streets in the northeast working-class neighborhood of Cleveland, where many immigrants had settled to work in shops. The young women raised funds for the church mission, sewed garments for the poor there, and held Sunday school festivals. They instructed girls from the neighborhood to sew, and while engaged in this activity, society members read to them from selected novels and inspirational materials and conducted discussions on the contents.[3]

Flora and her cousin Emma walked west from their Euclid Avenue home at East 13th through the Public Square to the Old Stone Church. On Sunday afternoons, the girls went by carriage to the Old Stone Church Mission to teach Sunday school. By 6:30 in the evening, the young people were back at Old Stone to attend the Young People's Meeting and would return again after supper with their parents for Sunday evening services. Prayer meetings were held on Friday nights. In short, church socials and entertainments occupied Flora's social calendar.[4]

In the years following their graduations from the Cleveland Academy, the young ladies of Euclid Avenue—Flora and Clara Stone, their cousin Emma Stone, and classmate and neighbor Kate Mather—had duties;

they were "to make their beds, dust their rooms and on Saturday clean the ornaments in the what-nots that stood in every parlor. Finally, they were elevated to arranging the flowers. In the afternoons they made calls." They were also engaged in benevolent activities, presumably awaiting the responsibilities of married life.[5]

In the decade following her graduation, Flora, "whose love of learning was always one of her enthusiasms," continued her informal education. All good literature interested her, especially history, biography, and essays on the arts, travel, and current events, and she took two long trips abroad with her family.[6]

In the winter of 1871, Clara and Flora traveled to New York City to visit their uncle Andros Boyden Stone and his wife, Amelia, in their temporary home there. Andros, the youngest in a family of ten children, was born on the paternal farm in Charlton, Massachusetts, on June 18, 1824, six years after his brother Amasa. He labored on the farm and attended the short terms of the district schools until he was sixteen years old. At that point, he was apprenticed to the carpenter's trade and two years later was employed as a foreman of bridge building by his brother Amasa and his brother-in-law William Howe. During the next ten years he was engaged in bridge construction in northern New England. In 1846, at age twenty-two, he married Amelia Boomer of Sutton, Massachusetts, and within two years they had twin daughters, Isabella and Arabella. From 1852 to 1858 the family lived in Chicago, where Stone had a factory that manufactured train cars as he continued to oversee the construction of many bridges under the Howe patents in Illinois, Wisconsin, Missouri, and Iowa.

In 1858, Andros B. Stone settled in Cleveland, where he secured an interest in a small iron mill that in 1863 was incorporated as the Cleveland Rolling Mill Company. He was its president from 1863 to 1878, during which time the mill became one of the largest in the country, employing in 1878 nearly 5,000 men. A Midwestern entrepreneur, Stone was also president of the Union Rolling Mill Company of Chicago, the Kansas Rolling Mill Company, and the St. Louis, Keokuk & Northwestern Rail-road. After a period of dual residency in Cleveland and New York, he moved to New York City permanently in 1878. In both cities, he and his wife were prominent in social, musical, and artistic circles and active in philanthropic work.[7]

During their New York visit to their uncle's home in 1871, the Stone sisters were introduced to a coterie of interesting young intellectuals.

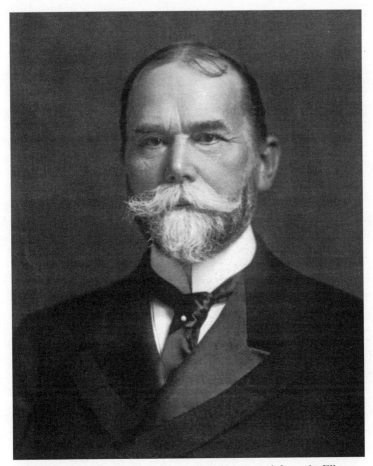

John Hay, journalist, diplomat, statesman, in a portrait by artist Ellen Emmet Rand, 1906. Western Reserve Historical Society

Among them was John Hay (1838–1905), an author and journalist for the *New York Tribune*. He had been private secretary to Abraham Lincoln and held several minor diplomatic positions in European capitals. Enamored of twenty-two-year-old Clara, John, eleven years her senior, saw her frequently during her winter sojourn in New York and continued his pursuit to Cleveland.

The engagement of the urbane and cosmopolitan John Hay and the reserved, pious Clara Louise Stone was announced in August 1873. Ecstatically, Hay described his fiancée as "a very estimable young person—large, handsome and good. I never found life worth while before." On February 4, 1874, Clara, twenty-four, and John Hay, thirty-five, were married "at

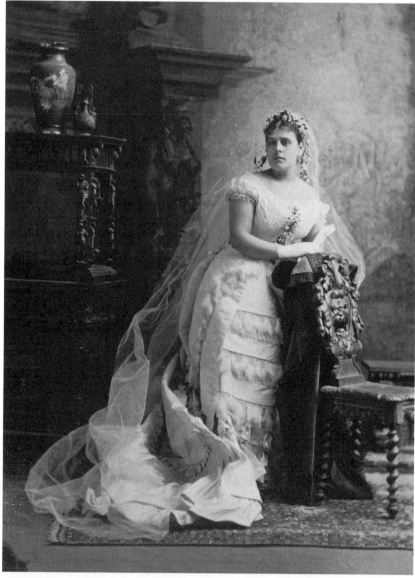

Clara Stone's wedding portrait upon her marriage to John Hay, February 4, 1874.
Western Reserve Historical Society

home on Euclid Avenue." One week later, they were situated in their New
York apartment at 111 East 25th Street in Manhattan.[8]

Amasa and Julia Gleason Stone had been reluctant to relinquish their
older daughter. Julia insisted on several postponements of the engage-

ment and marriage. The departure of their daughter from the family circle was too poignant a reminder of the loss of Adelbert almost ten years earlier. Julia was distraught and suffered insomnia.

Clara wrote to Flora on February 12, one week after her marriage: "Your very welcome letter came this morning and I am sorry to know you are so blue about my going away. You must be a good girl and not think too much about it because it will not be good for you."[9] John Hay assured them all: "Lady Clara is in fine spirits." Flora confided in her brother-in-law that when Clara was a child she was shy and diffident and lacked confidence. "Now I can see her fairly blossom out in the sunshine of her happy life."[10]

Clara Stone Hay embodied the qualities of nineteenth-century womanhood, the virtues of which included piety, purity, submissiveness, and domesticity. Her marriage to John Hay cast them as central players in America's Gilded Age. Clara dedicated her life to preserve the health and welfare of her husband: she followed him to locations at home and abroad; managed the household; reared their children; and took him to church, which he never joined. While she was not an intellectual woman and did not share in his literary work, Clara had knowledge of and an active interest in literature that was integral to the couple's relationship. During their courtship, John gave her books by authors both of them knew personally and admired, such as William Dean Howells and Henry James. She in turn selected works and read them to John, a practice that he enjoyed throughout their marriage.

Amasa Stone, whose health had continued to deteriorate, would not be consoled. He entreated the Hays to Cleveland with a job for John and a house he would build for them next door to his. In spring 1875, John and Clara Stone Hay, wed just over a year, were living with the Stones on Euclid Avenue while their home was under construction. At their new home, at 506 Euclid Avenue, their four children were born: Helen, 1875; Adelbert, 1878; Alice, 1880; and Clarence, 1884.[11]

John Hay took administrative assignments from Amasa Stone to relieve him of certain burdens. The most serious of these appeared on December 29, 1876, when an iron Howe truss bridge of the Lake Shore Road collapsed at Ashtabula, and a train carrying 159 people plunged into a ravine sixty-nine feet below; 92 people died in the wreck. Stone was held responsible for construction design and defects that caused the bridge's collapse. A subsequent investigation criticized the rescue effort and implicated

Amasa Stone, who had ignored the advice of professional engineers in designing the bridge and had insisted on using an overly long Howe truss span. Following the release of the findings, the chief engineer of the road, Charles Collins, committed suicide, and Stone's reputation was attacked. Amasa Stone testified and fought mightily to preserve his name. Despite his confident posture throughout the investigation, the acrimonious attacks overwhelmed him. He fled to Europe in June 1877, accompanied by Julia and Flora. This tragedy would plague him to the end of his life.[12]

John Hay's employment with Amasa Stone adversely affected his health, and he required respites. He used the time off to write *Abraham Lincoln* and *The Breadwinners*, a biographic novel based on his Cleveland experience. He was called to Washington, D.C., to serve as assistant secretary of state under Rutherford B. Hayes. In 1886, Clara and John Hay and their four children established a permanent residence in Washington, on Lafayette Square. The Hays had a passion for travel, and they were away from this home as often as they were from the one on Euclid Avenue. John Hay's occupations as an author and statesman had much to do with this: he went on to New York as editor of the *New York Tribune,* and he served President William McKinley as ambassador to Great Britain and secretary of state, a position he would hold under McKinley's successor, Theodore Roosevelt, until his death in 1905.

John Hay's presence relieved Amasa Stone of the crippling pressures of business, and the tonic of a brief European holiday in 1877 found Amasa and Julia Stone with Flora retracing their trip a decade earlier.

While on this journey, Flora corresponded with Samuel Mather, her friend and neighbor on Euclid Avenue.

June 27, 1877

My dear Flora:

May I beg you to accept these little Poems, and express the hope that as they may serve to recall to your mind fanciful legends and pleasant descriptions as you loiter through "The Homes of the Poets" in the "Old Country," they also occasionally turn your thoughts toward "The Land you've left behind you"—and toward one of the very sincere friends there whose best wishes for your pleasant journey and safe return go with you.

Sam[13]

The Douglas Hotel
Edinburgh
August 12, 1877

I want to thank you once again for those "Poems of Places." It was so very nice of you to give them to me as I was going away. One of them was my constant companion on board ship and I have enjoyed them much[.] I wish you would be good enough to answer a question for me. Two or three times before I came away, you said "in a laughing way—" "O Flora you are certainly getting demoralized." What did you mean, please? I *know* you meant nothing unkind Sam—be sure of that. But if you only meant that I am merrier than I used to be—why I am glad of that for I think it is a good thing to have fun and *make* fun in all innocent ways; It brightens up people about you. But if you meant that I seem more gay and less earnest—in short more frivolous—a woman of the world—then I wish you would tell me so but I am very much afraid, Sam, that you will answer me with kind & complimentary words—whatever you meant—but I beg you as my friend that you will answer me truthfully or not at all[.] I wonder if I have made you understand how thoroughly delightful your letter was. You have evidently "a gift" that way & I beg you to practice your art for my benefit. You cannot find a more grateful recipient, I am sure, nor one more appreciative than she who signs herself

Always faithfully your friend Flora A. Stone

London
September 25, 1877

Thanks for your kind words in answer to my questions. If you enjoyed those evenings just before I left half as much as I did—we shall try to have some more on my return. . . . Hoping to see you & the good old home faces soon, I remain, my dear Sam,

Very sincerely your friend. Flora A.S.[14]

Clearly the friendship between Flora Stone and Samuel Mather was advancing to another level initiated by Sam with his gift of a book of poetry as Flora embarked on her European travels. His accompanying craftily penned note indicating that he hoped to be remembered was in turn confirmed by Flora's eager and warm response. Each sought approval of the

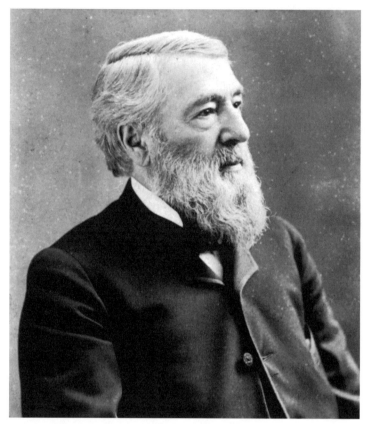

Samuel Livingston Mather, family patriarch and father of Samuel Mather.
Western Reserve Historical Society

other. Flora was particularly animated in her quest. With mutual respect
and affection, the two Euclid Avenue neighbors sought a new relationship
filled with hope and promise for the future.

Samuel Mather, son of Samuel Livingston Mather, traced his lineage
to Richard Mather (1596–1669), a noted Puritan minister who migrated
from England to Boston in 1635. Richard was the father of Increase
Mather (1639–1723) and the grandfather of Cotton Mather (1663–1728),
both also famous Puritan ministers. Timothy Mather (1628–1684) was
another son of Richard Mather, from whom Samuel Mather of Lyme,
Connecticut, and the Cleveland Mathers were descended.

Samuel Livingston Mather (1817–1890) came to Cleveland in 1843 to
represent and care for his family's Western Reserve holdings. His grand-
father Samuel Mather Jr. (1745–1809) was a shareholder and member of

the first board of directors of the Connecticut Land Company. He was married to Lois Griswold and lived in Lyme, Connecticut.

Samuel Mather Jr. and Lois Griswold Mather had eleven children, one of whom was Samuel Mather (1771–1854). He was also a shareholder of the Connecticut Land Company who in 1798 traveled to the Western Reserve to inspect the property of his father and other members of the company, though he never settled here. He did, however, inherit most of his father's property in the Western Reserve, where he also purchased land for himself. He was a 1792 graduate of Yale University, was married to Catherine Livingston, and lived in Middletown, Connecticut.

Samuel Livingston Mather (1817–1890) was one of nine children born to Samuel and Catherine Mather, and he was responsible for the Cleveland branch of the family. In 1835, he graduated from Wesleyan University in Middletown, Connecticut, and was admitted to the bar. In 1843, the European-traveled New York businessman Samuel Livingston Mather came to Cleveland as a real estate agent on behalf of his father's interests. Here he abandoned ideas of a legal career to become a pioneer in the iron ore industry in the Lake Superior region. He developed properties with local capital by organizing the Cleveland Iron Mining Company in the early 1850s. The company was the parent of industrial concerns that had vast operations in the great Marquette ranges of the Iron Mountain district.[15]

Georgiana Pomeroy Woolson (1831–1853) was the eldest of the eight daughters and one son of Charles Jarvis and Hannah Cooper Pomeroy Woolson and a grandniece of author James Fenimore Cooper. Her parents visited Cleveland in the summer of 1839 from their home in Claremont, New Hampshire. The following year, having lost three of their young daughters in three weeks from scarlet fever, Mrs. Woolson's health was so shattered that they left their home and settled permanently in Cleveland, where Mr. Woolson started a new business and began life again.[16]

Georgiana Pomeroy Woolson was nineteen when she became the wife of thirty-three-year-old Samuel Livingston Mather on September 24, 1850. Allusions to her radiant and magnetic personality were recorded in her mother's journals and by her great-uncle James Fenimore Cooper, who wrote his niece Hannah following her seventeen-year-old daughter's visit: "Georgiana was with us just fifteen days; long enough to make us all love her. You have every reason to be satisfied with your daughter, my dear. She is a social favorite here. To me she appears to be ingenuous, very warm-hearted, sincere and quite alert."[17]

Georgiana Pomeroy Woolson and Samuel Livingston Mather enjoyed a brief but by all accounts ideally happy married life. They had two children: Samuel, born on July 13, 1851, and Katharine, born on September 3, 1853. Two months after Katharine's birth, Georgiana, a victim of consumption, died on November 2, 1853. She was twenty-two years old.

Three years later, Samuel Livingston Mather, left with two young children, married Elizabeth Lucy Gwinn (1824–1908) of Buffalo. Elizabeth Lucy Gwinn was the daughter of William Rea Gwinn and Hannah Evans Gwinn of Buffalo, New York, where the Gwinns were an affluent family. William Gwinn had interests in the Fort Smith and Western Railroad Company, the Hickory Farm Oil Company, the Lake Superior Ishpeming Railway Company, and the York and Liverpool Turnpike Company. His business interests overlapped with those of the Mather family, and this undoubtedly brought his daughter Elizabeth into contact with her future husband, Samuel Livingston Mather.

Elizabeth Lucy Gwinn was thirty-two years old when she married thirty-nine-year-old Samuel Livingston Mather. She came to Cleveland and to a young family that included Samuel, five, and Katharine, three. A second son, William Gwinn Mather, joined them on September 9, 1857.[18]

The ties between families related only through marriage remained after the death of the linking family member. The parents of Samuel Livingston Mather's first wife referred to William Gwinn Mather as their grandson. William also addressed the Woolsons as his grandparents, though his mother was a Gwinn and not a Woolson. Samuel's two children by Georgiana Woolson referred to Elizabeth Gwinn Mather as their mother.

In October 1865, Samuel, who was attending Cleveland High School, was staying with relatives in the east and looking at colleges in New Haven with the approval of his father, who wrote, "They are very old and well worth seeing." Later, he informed Samuel: "Kate had a party tonight—invited some 12 or 13 boys and girls. She says she will give your message to the *one* you wished her to. Willie is very well and practices the piano everyday. He wants to play as well as you. He is a dear little boy and keeps me well posted about all outdoors connected with the Garden and Barn."

In August 1866, Mrs. Mather, Kate, and Willie—vacationing in Wisconsin—joined Samuel's father in Chicago, having deposited fifteen-year-old Samuel at Marquette, Michigan, for an introduction to the operations of the Cleveland Iron Mining Company in the Upper Peninsula.

Within the next week Samuel received a series of instructive letters from his father.

I like your new boarding house and Mrs. Everett. I know they will be kind to you and I hope you will have a good time and gain strength and not get sick. . . . Write often and tell me all that you do and all the news of Marquette. Keep your person clean, your teeth and ears especially—and also your linen and handkerchiefs. Thank your Uncle Henry [Samuel Livingston Mather's brother] for all his kindness to us.

Sending you a pair of Eye Glasses, No.9 the best kind that won't break easily. The price is $3.50 . . . charged to you. I am going to make you pay for them.

Take a little more pains with your writing and manner and style of writing. You are now old enough to be noticed and your letter looks rather careless. I hope you don't give any trouble to the Everetts—that you don't neglect your daily duties of prayer and reading the bible and also that you don't leave your clothes around loosely. Be clean with your teeth and nails and also be polite.

Stay at Marquette as long as you like[,] only be down a few days before your school term commences—perhaps the Ironsides will be coming down about that time and it will be a good Boat to return in, the Capt. will take good care of you.

One year later, in 1867, Elizabeth Mather met Samuel in Boston and together they went to Southborough, where Samuel would attend St. Mark's School. His father was anxious to know how he liked his "future home for a year or two. . . . You must see the sights—Faneuil Hall, Bunker Hill, Cambridge Colleges, every part of Boston and all its surroundings, all interesting and historical as connected to our Revolutionary War—besides it is the home of your ancestors—the worthy, learned and pious *Mathers*."

By late September Samuel received word from his father: "I am anxious about your cold and sore throat. I fear you are not prudent enough—don't sleep near an open window or suddenly cool off after a violent exercise at Ball. . . . Play moderately no matter if you don't play as well as some others. You must not go beyond your strength. We miss you very much at our Table at the morning Family Devotions and at all hours." Finally, recognizing the xenophobic tendencies of the eastern seaboard residents,

he advised, "Don't be frightened at the boys laughing at the *West*. It is the hope of the country and its main support. You should be proud of being a Western boy." In yet another admonition, he noted, "Mother has got a box for you with a lock on it . . . to keep your papers in. Keep all your letters private, so that none of the boys can ever see them."

In early October Samuel Livingston Mather wrote:

My Dear Son:

I will tell you why I am so anxious about your health and frightened when you catch a cold. It is because you are not constitutionally strong, and that your tendency is toward weak lungs. You know that your mother died of consumption brought on by taking a cold, and neglecting it, until it fastened on her lungs. She was always healthy until then and was sick about a year. You also know that your grandfather [C. J. Woolson] is by no means a strong man, and that he has to take the greatest care of his health, and particularly is careful about taking a cold, for fear it would at once settle on his lungs and bring on consumption. [Mother] wants you to wear now warm socks. Can you buy them at the store, or shall she buy them and send them on to you. *Don't get your feet wet—be very careful about that.*

Early in his senior year at St. Mark's, Samuel received a father's advice and counsel: "The trials and struggles which you say you have are the same or similar to what we all have. It is the same in all ages of men, only perhaps a little different in character and I am glad you meet them manfully and strive against them." On the arrival of Samuel's fall grade report, which his father found gratifying, he remarked, "We think more of our children than we do of ourselves and are willing to make great sacrifices and are fully repaid when they do well."[19]

And so the exchanges continued in an upward trajectory throughout young Samuel's senior year and graduation from St. Mark's with maturity evidencing itself in the youth in conjunction with his father's expectations and, thus, satisfactions.

Samuel was scheduled to enter Harvard College in 1869, following a summer working in Michigan as timekeeper and payroll clerk for his father's Cleveland Iron Mining Company. In Cleveland, Samuel Livingston Mather received a letter dated July 16, 1869, from his brother Henry R. Mather, who lived in the area and supervised the family's mining interests.

Its contents had significant consequences for Sam; the course upon which he was set would take a dramatic turn with lifetime ramifications beginning with his expectation to matriculate at Harvard.

My dear brother,

Yesterday afternoon, Sam had quite a severe fall, which may lay him up for some time.

It seems a shot had been made in one of the openings, and Sam being anxious to see the result, incautiously stept upon a small ledge—about 10 feet high, immediately under the loose rock. A large piece of this fell, striking Sam on the hip, and throwing him head foremost on the ore below. His head is badly cut in several places, and in one place the skull is slightly fractured.

His left arm near the elbow, and his hip near the spinal column is quite badly bruised. Dr. Hewitt and myself went up this morning to see him, we hearing of it after having gone to bed last night. Dr. Bigelow was in attendance having been with him most of the night and bestowed every attention possible upon him.

We found him in good spirits, bearing up bravely. He did not want us to telegraph you, fearing it would alarm you unnecessarily, but the Dr. & I upon consultation, thought that if anything serious should happen, you would blame us, and if not, no harm would be done, concluded to send you the message.

It is impossible to tell at present the extent of the damage. If inflammation can be prevented he will be all right again, in a few days, but otherwise, he may have a severe time.

A small bone connecting with the spinal column is thought to be broken. From that may come partial paralysis, or not. When the reaction sets in, we can tell better the extent of the hurt. Both Drs. Bigelow & Hewitt, at present think he will most probably get along with nothing more than a temporary confinement and some suffering, but still they feel a little doubtful. I think it would be as well that you should hasten your visit a little.

Mrs. Morse went up with us, and is kindly attending upon him today. If you could bring a nurse along, it would be as well, for we have searched Marquette, as well as the mines, & can find no one.

I hope & trust that nothing serious may happen, it looks well today, but still, I would rather you should be here, & look personally

after him. I shall take Mary up as often as possible & we will do all that can be done for his comfort & welfare. He is a noble fellow, and bears up wonderfully.[20]

Young Samuel convalesced for two years, to repair his skull, spine fractures, and the neurological damage that would leave him with a permanently impaired left arm. In 1870 he returned to Marquette with responsibilities commensurate with his physical limitations. By 1872 he had recovered sufficiently to travel in Europe. In 1873, his recuperation completed, he rejoined the Cleveland Iron Mining Company.

1877–1881

*I love your conscientious devotion to duty . . . your untiring energy
and cheerfulness of spirit.*
—Samuel Mather to Flora Stone, *1880*

Flora Stone and Samuel Mather, children of Cleveland's Euclid Avenue, exemplified the people who made up their neighborhood. The values of their New England forbears were carried out in their homes, work, schools, churches, and social lives. Their union would perpetuate the definition of the character of the grand avenue where they would dwell.

In the 1850s Euclid Avenue established its position as the city's premier residential street. Cast-iron fences installed by all the residents reinforced the neighborhood's exclusivity by preventing the inquisitive from seeing the mansions. Yet among these resplendent homes and their exquisitely landscaped gardens, the residents of the linear neighborhood knew no boundaries. For four miles, one yard flowed into another, creating a parklike setting of landscaped lawns, finely pruned shrubbery, and shaded walkways. Almost everyone knew everyone else, at least casually, and each family belonged informally to at least one of the many coteries that distinguished one block from the next. Neighborhood friendships developed that often led to marriages, which strengthened the fabric of this community.

The home and family were at the center of this universe, where the values and culture that perpetuated an urban leadership of several generations were instilled. The second generation who lived on the avenue in

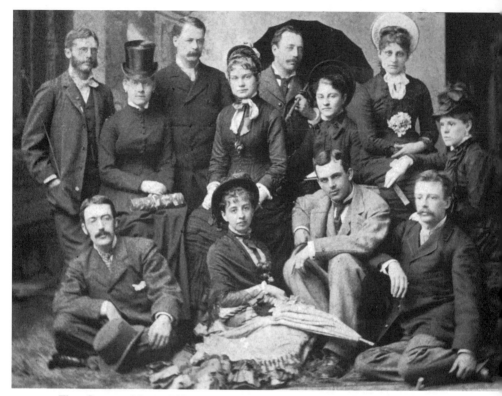

Flora Stone and Samuel Mather (center front) *with their Euclid Avenue set of friends, ca. 1871. Western Reserve Historical Society*

the post–Civil War decades was raised in the manner and tradition of their parents. Most were natives of Cleveland, some even having lived on the avenue since childhood. They had inherited their parents' Puritan values along with their wealth and enterprise.[1]

Amasa Stone and Samuel Livingston Mather built their Euclid Avenue homes in 1858, just doors away from each other. The Stones' Italianate villa was at 514 and the Mathers' Tuscan-style home at 383. The Amasa Stones hosted a housewarming party in January 1859 for "a throng of old settlers" and "the beauty and fashion of the Forest City" just after their house was completed.[2]

Those who grew up on the avenue became acquainted quite naturally. Many went to school together, attended the same parties, joined the same clubs, and dined with one another. Business relationships were strengthened by social gatherings; many of the men worked with one another in

the same industry or in joint ventures, often meeting in the crossovers between professions. Also, the Stones, Hays, Mathers, and their fellow Clevelanders were active in the national arena and were well acquainted with many of the country's leaders in politics, commerce, and culture. Ohio was the state of presidents in the postwar decades; and in Cleveland, its most influential city, Euclid Avenue residents were prominent in the national network of establishment politics. So whatever the connection, social or professional or political, from childhood through old age, these denizens of Euclid Avenue assumed they were inevitably connected with one another in a distinct community.

Neighbors Samuel Mather and Flora Stone were no exception. When young Sam was away from home—at work, at school, or traveling—he regularly inquired about and asked to be remembered to his circle of friends. Flora Stone consistently received mention. While their lives had taken several turns both predictable and unpredictable, in the 1870s their steadfast bond was their Euclid Avenue experience.

Beginning in 1870, Euclid Avenue families went up to Little Mountain in Lake County, Ohio, to enjoy the outdoors and one another. Occupying small frame sleeping cottages, everyone gathered to spend their days and evenings eating, drinking, and dancing at the big hotels surrounding the mountain. In 1872, joined by Samuel Livingston Mather, Amasa Stone and other neighbors bought the Stocking House for $7,000, and it became the Little Mountain Club. Among the location's attractions were hikes along winding mountain trails through fields of wildflowers, caves and caverns that offered cool sites for exploration, and refreshing natural springs.[3] America's class of socially eminent families was quite congenial among its own. They traveled often and saw one another frequently. Euclid Avenue families, convivial by nature, settled in groups, choosing places that offered leisure-time activities that they favored. Many found pleasures at seaside resorts and mountain spas. Often seeking rest in solitude, they went on long retreats to rejuvenate their constitutions.

Within the sphere and influence of the Euclid Avenue experience, Flora Stone and Samuel Mather fashioned their lives. Samuel Mather could not pursue plans to attend Harvard College as a result of his accident in Marquette, and Flora did not seek advanced education either. Her role was preordained: she would be a wife and mother and succeed in both with the establishment and maintenance of an exemplary household. Over the next six months, late 1879 and early 1880, Flora and Sam wrote regularly

to each other. Their expressive, intimate letters chronicle the growth of their relationship and reveal their deeply held feelings and capture beautifully the nineteenth-century style of courtship, where through letters they addressed hopes and fears, desires and dreams.

[late 1879]

[Dear Sam:]

For the last six months I have found myself relying upon you, needing you, & it would be you who would help me, not I you. . . . If it was by being with me & talking with me, can I not help you almost as much as though I had given you a different answer? There is no one in the world, not even in your own home, I feel sure, who cares more for the *slightest thing* that in any way concerns or interests you than I. Perhaps it is because you care more for me than anyone else, except my mother, but I think it is more for what you yourself are to me, that I care so much for you. It does me good to think of you. I *trust* you perfectly, & that is more than I can say of almost any one else. And so, will you not come to me with every thing that interests you, every thing especially, that troubles you?

For the last month we have, to a certain extent, *made* conversation. You have felt under restraint with me, & I did not know what to say to you. One cause, I think of my blunder was that I always talked to you about myself & my affairs & you rarely spoke of yours. I have always been afraid of you, Sam, & dared not ask you about yourself or your concerns lest you should think me intrusive & impertinent, but now *please* come & talk to me.

[January 14, 1880]

Dear Flora:

We are vacillating creatures not always of the same mind. My idea was "she either loves me well enough to blot out the past notwithstanding & in spite of the past or, she does not" and I must find out. I was somewhat disheartened to find that you could not respond affirmatively, and thought not to do anything to affect your decision, simply because I felt so blue about myself that I hesitated to urge you to accept such a fellow. But as I lay awake last night in the sleeper thinking it over, the idea of losing your love, if I could gain it in any way became unendurable and I am writing you now immediately

upon arrival before breakfast. For I love you deeply, Flora, and long
to tell you so and show it to you. I long to kiss and caress you and I
long to hear and know that you love me with an equally ardent and
demonstrative affection. I love your conscientious devotion to duty. I
could not love any one over a week that was without this quality and
I love your untiring energy and cheerfulness of spirit. As I think of
these things in you that I love, I fail to see what there can be found in
me to excite a responsive feeling in your heart, and yet I must trust
and hope that you may find or think you find, something there. If
you can find it, I care not, if the whole world fail to discover it. Flora,
I am longing to have you love me, and to have you show it, and to
have you think more of me than of any one else. But unless you can
do this, and can let the past be an oblivion without allusion hereafter,
it will be better I fear for both of us to have this settled at once. If you
can love me as I love you and as I want you to love me, it will be as
a tonic to my whole man and make me a new man. . . .

Flora and Sam basked in the glow of their deepening affection. While
they had not yet disclosed their relationship to family or friends, they ex-
pressed amusement that their rapturous state had not elicited comment.
Throughout their courtship during the spring and summer of 1880, they
were frequently separated, though they corresponded devotedly between
Samuel's work place in Ishpeming, Michigan, and Flora's vacation ad-
dress at the Crawford Hotel on the East Coast.

[June 12, 1880]

[Dear Flora:]

My dearest, I don't dare put on paper all the love I want to ex-
press to you. I don't even know how to express it to you when I am
with you. I've been, for various reasons, repressing myself & living
a double life for so many years that I find myself taking in a matter
of fact way what is to me in reality a very beautiful & mysterious &
wonderful thing. My whole life is changed & brightened, and yet I
act just as I was. Oh my darling, think of something you want me to
do for you *that* would make me very happy.

And then Flora, when our aims and purposes, as our hearts, shall
be one, and we shall be together constantly, I trust that I shall grow
more light hearted and joyous, and with a happy heart, forgetting the

past, live to make you happy always and never regretful of having entrusted yourself to me. This I hope for, with God's help.

[August 2, 1880]
The Crawford House

What I do fear though, Sam, dear, & I fear it very much, is that since you are so very sensitive, I shall unconsciously say things which shall hurt you & you will just be hurt, & say nothing. You know I am very impulsive, but perhaps you don't know that I have not much tact to feel "which way the wind blows." Some day you will come home, when things have gone wrong at the office & you are all on edge, or you'll have a headache or something, Sam dear. I want to be a cushion at such times, not a thorn, and you must help me to find out how to suit myself to your moods. I do try now, but I know I'm stupid at it. I don't want to pet you when you don't want to be but above all things I don't want to be lacking in expressing my love, when *that* is what you need.

[August 6, 1880]

[Dear Sam:]
I could tell you (but I cannot write it, for those times often hard on paper, which with face and voice to interpret are perfectly understood) that you are in many ways different from the man I imagined myself loving. But never the less I love the boy, now a man, whom I have known for years. Doubtless I shall discover many unexpected things in you.[4]

The passage of courtship as revealed in the letters exchanged by Flora and Samuel mirrored the culture within which they lived and reflected "the Euclid Avenue experience." Born into established families, both Flora and Sam were thoroughly versed in the rituals of their parents' lives and their society's marital expectations. At the same time, their deep and abiding affection for each other soars in their expressions of tenderness, longing, humor, and joy. Their relationship was more than simply a convenient one designed to unite two families' values and property. Theirs was a love match, and a passionate one.

Amasa and Julia Stone gave their blessing to the proposal, and the news of Sam and Flora's engagement circulated among friends and family. The

marriage of Flora Stone to Samuel Mather indeed had the full approbation of Amasa Stone. A union with the Mather family offered economic and social ascendance into the highest ranks of Cleveland society.[5] As a young man, Samuel worked for his father's Cleveland Iron Mining Company, where he rose to a leadership position, and he and his brother, William, would eventually control the corporation. During their courtship, Samuel sought his future father-in-law for consultation on business matters, and Amasa Stone readily supplied it.

As was usual in their relationship, Sam and Flora were more often apart than together immediately following the engagement. Sam was away on business in Detroit and Ishpeming when he conveyed to Flora his family's delight with the news, and especially on the matter of Flora's attendance at his family's Episcopal Old Trinity. He, in turn, was eager for reactions from 514 Euclid Avenue. Flora excitedly described every conversation with family members and especially those with her father, whose opinion was of particular importance to the young couple. She also described an important encounter with Sam's father, during which she shifted from a formal to more natural mode of conversation, one befitting a future daughter-in-law. (In an endearing admission that is evidence of her eagerness to please her new fiancé, Flora asks for Sam's help: "Make a note of all the words I misspell & tell me when you see me. I am naturally a bad speller & naturally careless. Sometimes I know better, & it is evidently that it is a blunder, but sometimes, I grieve to say, it is pure ignorance, & I don't want you to be ashamed of me. I will not be hurt. On the contrary I am very grateful when Col. Hay occasionally corrects me about some little thing. . . . I am trying to correct little habits, which I think might annoy you. I do not dare to say I try to write plainly for you, for I usually write in too great a hurry. In short, I love you so much that I want to please you in all things.")[6]

In the opening months of 1881, Flora visited Washington, D.C., where Clara and her family lived. While there, she participated in "the Washington scene" available to her as the sister-in-law of Assistant Secretary of State John Hay and enjoyed the chance to spend time with her sister, nieces and nephews, and longtime friend—and future sister-in-law—Kate Mather, who joined Flora at the Hays'.

In their letters, the engaged couple bridged the time and space by detailing daily goings-on, both mundane and exciting. Flora's letters read

like diary entries and filled Sam in on the routine events and conversations of the Hays household as well as shared her excitement over people met and sites seen. She offers explanations for her behavior with touching openness, asking not for Sam's approval but for his understanding and help with troubling issues. Sam, equally candid (but more concise), writes of his health problems (poor eyesight, pulmonary weakness, neurological damage, and general physical impairment) and expresses concern that Flora understand that these infirmities are manifest in his seemingly irritable behavior and do not reflect on her behavior. Throughout the exchanges and underscoring their eager learning about the other, Flora and Sam can barely contain the excitement and eagerness at the promise of their shared future.

[December 30, 1880]
Monongahela House [Pittsburgh, Pennsylvania]

[Dear Flora:]

Now, my darling, you know that my affection for you is of a kind that "wears." It is not based on affinity of soul, alone. There is gratitude in it, for all you have been to me: there is the strongest esteem[,] indeed it is based on that, and though not having the poetic temperament, I do not wax "excited" and have "sensations" at the sight of you or the touch of your hand, yet I feel that our hearts and our understandings grow closer together every time we meet. There I think we are destined to be happy, not alone through courtship & the Honeymoon, but all through the years of our married life, and by mutual love, understanding, and forbearance, to become dearer to each other as the years roll by and we become old together.

Flora responded on December 31, 1880, from Washington, D.C.: "Almost always one goes over one's life these last days & plans a little for the future—but my new year, my "new day" began last spring & I have no thoughts for a resolution this coming year. Nevertheless I so want to make some changes, some improvement."[7]

When Flora first arrived at the Hays' Washington home, she was greeted by her young niece Helen, who exclaimed "My! How fast you talk." In her letters to Sam, this observation was later expanded upon with other examples that revealed Flora's sensitivity about her manner of speaking and her concern about her interactions with people. She attributed her behavior to the influences of her parents.

I don't talk very much in private. [Kate] thought at first that I was offended with her, because I was so quiet, often when were alone together. I don't think it is a nice trait, to be talkative in company & then have nothing to say to your own people, but sometimes, after I've been excited & couldn't help talking, or had to make an effort to be agreeable to a difficult person, I seem to *collapse* & find it physically impossible to say another word.

We never were a talkative family, until lately, among each other. My Father, when we were little, was too busy & preoccupied to take any notice of us, & you know that my mother is usually very quiet. Since we have grown up my father has tried to talk more, & when he and I are alone together we get on beautifully. Clara & I often walk downtown together & never say a word & yet I enjoy being with her.[8]

Within the confines of what might be considered proper conduct for a nineteenth-century woman is the individual story. The candor with which Flora wrote to Sam expressing physical longings as well as personal shortcomings speaks to the trust borne of their relationship and the deepening of their commitment to each other. They also discussed in their letters their different yet complementary social styles, an important part of their relationship since both were shaped by Euclid Avenue traditions.

[January 31, 1881]

Sam, how glad I am that Providence has wisely put me in a quieter sphere than this. I fear even you, who likes me to be jolly, would have said I was *too much* demoralized if you could see me now. It is not so much about what I *say*—perhaps,—though I am sometimes outrageous, but I don't believe anyone would ever know I had any principles (except total abstinence) & if you knew what frivolous thoughts I have even in church, you would be shocked. My thoughts of you are the best I have & luckily for me they are not infrequent, dear love.

[February 7, 1881]
Cleveland

Dearest Flora:

Your "chronicles of daily doings" were very short this morning: far from tiring me. I am much interested in your accounts of the festive times both in New York and Washington that you have been

having, though of course it would all have a more living, personal interest for me if I were acquainted with all the bright people of whom you discourse.

I don't think I care so much to knowing "new" people all the time, as you do. Your energy is more indefatigable than mine, and I somehow feel content to use mine to try and "clasp to my soul with hooks of steel," (Is this correctly quoted?) the friends whose worth I know.

'Tis better, however to do both, my dear. You hold all your old friends and gain new ones also. It takes me some time to arouse any very sincere interest in new acquaintances, not being confident enough in my knowledge or ability to read character, to feel sure of them until I see them outside of society life.

Flora responded, explaining:

Yes, I do like to meet new people dear, I suppose it comes from a restless nature, partly, though the reason I give to myself is that *maybe* they'll be very nice, & I want to find out. I always think of what Dudley Warner says so neatly & which I must quote so clumsily. When he made a new friend he said "Think of all the years I might have known you & didn't—and oh, think of all the nice people in the word I *never* shall know." I want to know the best & the cleverest people, & every new acquaintance *may* (but very likely doesn't) prove one of that sort.

And yet, strange to say, I am much shyer about meeting strangers than Clara, & don't just get on with them as well as she does. Another thing is odd, too, I, of all people, ought to be a judge of character, for in my work at home it is part of my business not to be imposed upon, & yet I seem to drop all that in intercourse with my social equals, & I am constantly, even now, giving myself too freely, & finding I am disappointed, draw back with what dignity I may. But after all is said, I still do enjoy meeting new people; there is always the interest of the unknown, & I'm willing to take the sour with the sweet.

This applies to "away from home." *At home* I am more than ever convinced that it is best to have a few dear friends & make the most of them, rather than spend oneself ineffectually on the world at large.

During the course of their engagement, Flora, among her frequent trips and travels, fulfilled her charitable responsibilities with the Young

Ladies Temperance League, the Day Nursery, and the Old Stone Church Sunday School, while Sam remained occupied with the demands of his family's iron ore business. Despite their considerable time apart, through correspondence the couple worked through the practical issues of their impending marriage—their plans for the future, their home, the attendant responsibilities of roles within marriage.

While practical matters could be successfully handled through correspondence, the personal dimension of maintaining a romance long distance presented a challenge for Flora and Sam, though the young couple met the challenge with a mutual sensitivity and understanding that portended well for their future. One proposal for an earlier wedding date, broached by Sam, however, had a dramatic and troubling effect on Flora, unleashing expressions of doubt and anxiety in her letters. Parental approval was paramount, and Flora worried that her mother would find it impossible to plan for a wedding in only three months, and momentary questioning also interrupted her own romantic thoughts of the wedding (though, realistic as she was, she still made regular trips to New York to buy dresses and complete her trousseau). Interspersed with her words of self-doubt were those of an understanding Sam consoling her in the belief that they would build a happy and fulfilling life together.

[July 21, 1881]
Cleveland

[Dear Flora:]

I should not have felt in a fault finding mood if I had been feeling stronger & "weller." That however is no excuse[,] for my eyes will probably always trouble me more or less and I cannot expect now even to attain that degree of strength & elasticity that it has been the hope of many years to reach, "sometime." "Sometime" I was to have four[,] five or six months of out door life in some healthful beautiful country place, there to get such a good substantial start & foundation that it would be a comparatively easy matter thereafter to gradually build upon it by moderate living and an occasional short vacation.

You are laughing and so am I at what I have just written you, but it is a real fact that is seldom out of my mind—if I were only strong as the generality is expressed in a few very plain English words— that I am often ill-tempered. Well, then, knowing you so well as I do, and with the confidence I have in your love and real goodness

of heart and loving you so really and thoroughly as I do, it certainly proves that I am ill tempered that sometimes I am "put out" by little nothings on your part.

[July 22, 1881]
Saratoga

[Dear Sam:]

No, my dear old fellow I did *not* laugh, even if you did, for I sympathized very much with your feeling. I understand my dear, that you're not excusing yourself, you're only explaining. . . .

But Sam, it is a comfort, though perhaps a weak one to think, when one is utterly discouraged with one's self. It will be all right at last, we "shall be satisfied" in Heaven. There will be no hindrances there.

Meanwhile, I want to ask a favor of you. Don't say you can't do it, for I know you can if only you are not afraid I will be hurt. Tell me of some of the "nothings" that have annoyed you. . . .

I would be more than human, I think, if I did not feel a little vexed at the moment of correction, so if you will tell me *now*, before I offend again, it will save that little bit of temper, for if you tell me *in cold blood*, I promise you I will not be in the least vexed. I *know* you can think of a half a dozen little habits which, perhaps, could be easily corrected. Give me a chance, my dear, & if then I annoy you again, give me a scolding. I shall deserve it, & if you *don't* tell me, you must bear half the blame of your own ill-temper, sir.

But now may I find a little fault with you, Sam? Why did you accept & then change your mind? That is quite a habit of yours, do you know? You said you had no good reason for declining. A good reason is not necessary for a large party, I should think. It seems to me that you ought to make up your mind that you will or will not do a thing, & then unless you have a very good reason for changing, *stick to it*. I know you often put the family out because they don't know what you're going to do, you will not say.

You hate plans, I am trying to keep that in mind, & in many things it is not necessary to make plans, so I am trying to teach myself, but in the matter of engagement, or rather perhaps of invitation, I think you *should* decide.

Now, sir, having "practiced what I preached," I shall expect a long sermon from you on my short-comings. I wish I were clever

enough to write an awfully spoony letter & send it to your Father as if by mistake. It *might* be a capital joke, but I am afraid to try.[9]

But ultimately, and once again, it would be a parental decision exercised by Flora's father that would decide about the wedding. Amasa determined that, as with her sister, Clara, Flora would be married "at home on Euclid Avenue."

With their wedding day just six weeks away, Sam and Flora exchanged letters of tenderness and honesty that reflected their deeply held religious beliefs regarding the human condition. The arrival of gifts, the joyous anticipation of their union, and the delights of a European honeymoon carried Flora and Sam forward in the days leading up to their October 19, 1881, wedding day.

> [September 28, 1881]
> Cleveland

[Dear Flora:]

I am writing you the second time today, not because I have anything particular to say to you, my dearest, but simply because it is one of my blue days and I wish that you were here. As you are not, I naturally sit down to write you.

The sky is dark, my spirits are low and I seem unable today to accomplish anything satisfactorily. And not only the hours that are going to waste today seem to rise up to reproach me, but all the ill spent hours in the past are parading themselves before me. And seem to say to me "as an inevitable consequence of good habits *not* formed in the past we will soon be joined by hosts of murdered hours in the future."

Exertion, when oppressed by such thoughts, seems paralyzed, or when exerted, seems illy directed and futile.

Are we to be held strictly to account for idle hours, idle words, and all misspent opportunities? These, if heaped on top of actual transgressions, will make a burden heavy indeed to bear. And how about the sins we commit in thought, even though not in deed?

We are all in the same category, poor human mortals all of us. And at least can have full sympathy and mutual love and forbearance one with another. Knowing our own shortcomings so well how is it that we are otherwise than kindly and gentle towards, others?

And yet sometimes we would rather do as we please at all hazards, apparently.

Write me a long and loving letter, Flo. I believe I am more dependent on human affection than I need to believe I was. It seems more to me, as I get older, and supplies a craving that was not felt before.

[Dear Sam:]

Sam, my own dear love, no, we have *not* to give account for all our misspent moments & opportunities in the way you fear. I suppose we must give an *account*, for the Bible says it will be for "*every* idle *word*." Poor me! But that is to God & your idea is that because of the ill-spent hours we have less chance of spending the future ones properly. That is true no doubt, the groove is worn & the water naturally flows there, but it would be very weak character, you are not that would make such an excuse. Do you know, I believe God pitied the depression & discouragement that comes from physical exhaustion just as a mother loves & pities her little feeble child. I don't believe He counts as sins of omission or commission all our foolish & rebellious acts & thoughts. Perhaps I am getting into deep water. *I* know what I mean, but I fear I'm not making myself clear. Besides, you don't want it now—maybe—if the weather is cooler & you have slept well, you are properly working away with energy at all sorts of disagreeable tasks, just to prove to yourself that you *can* overcome them.[10]

In a small leather-bound book she titled "Wedding Presents," the bride-to-be recorded 170 gifts from family members, Euclid Avenue neighbors, and friends. Flora's mother gave the couple personal gifts of a watch chain for Sam, a Spanish lace shawl and a fan for Flora, and, for their home, a silver tea caddy and a set of silver forks and spoons. Amasa presented them with a silver set, a brass clock set, and Lake Shore and Michigan bonds. From Clara and John Hay they received dinner coffee cups "with pot [and] creamer." Mr. and Mrs. Samuel Livingston Mather gave them checks, a diamond scarf pin for Flora, a dressing gown for Sam, and a silver fruit dish, sugar bowl, and creamer. From Kate Mather Flora received a pearl lace pin. William G. Mather gave the couple a cut-glass fruit set and his brother a half-dozen handkerchiefs. From their Euclid Avenue neighbors and friends familiar with their tastes in literature and art, Sam and Flora received paintings, etchings, engravings, photogravures, books,

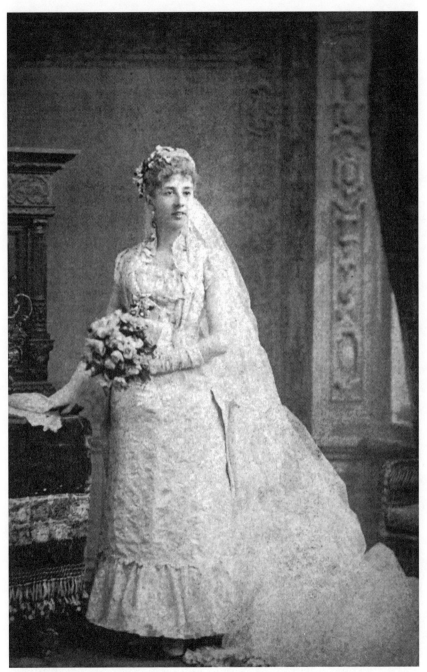

Flora Stone's wedding portrait upon her marriage to Samuel Mather, October 19, 1881.
Western Reserve Historical Society

an encyclopedia set, a full set of Shakespeare's works, and *The Encyclopedia of British and American Authors*. One such gift in particular delighted Flora, who wrote to Sam, "Could anything be more delightful & elegant than a complete set of Thackeray in half calf?"[11]

At last, after months of planning and anticipation (with Flora even expressing to Sam a common sentiment among brides: "How glad I shall be when all this is over. I wanted to be married without any 'fuss' or hurry & have the wedding always a pleasant memory, but I believe it is inevitable that one should get out of breath & fret a little. If I ever seem impatient & unstable when I get home between now & the nineteenth, forgive me & love me for I don't mean to be horrid to you"[12]), their longing for marriage expressed many times in their courtship and correspondence became a reality when on Wednesday, October 19, 1881, Flora Amelia Stone and Samuel Mather, ages twenty-nine and thirty, were married at her family's home on Euclid Avenue. The following morning's edition of the *Cleveland Herald* announced:

MATHER–STONE
A Quiet but Elegant Wedding of
The Avenue Last Evening

The 7:30 P.M. ceremony was performed by the Reverend Dr. Arthur Mitchell of the First Presbyterian Church, the spiritual home of the Stone family. There, in the presence of a company of relatives and friends of both families, numbering around 150, Flora and Sam exchanged their vows. Attending the bride were Sam's sister, Kate, and Flora's friends Julia Parsons, Emily Fabian, and "Misses Boardman and Younglove." Acting as groomsmen were Sam's brother, William, and Cleveland friends James J. Hoyt, A. G. Stone, and Henry C. Rouse and A. A. Adee from Washington, D.C.

Rich and tastefully appointed, the wedding was described as a "quiet, unostentatious, elegant affair."[13] The sumptuous reception that followed was in keeping with the Euclid Avenue tradition. Two of Cleveland's prominent and most highly respected families were united, and the ecstatic couple basked in the warmth of the company of approving, loving family and friends.

The next day, October 20, Samuel and Flora Stone Mather, husband and wife, embarked for the east and a European honeymoon.

1881–1900

*What touched me most and made me most glad of you, was that
you said we would try together to live naturally, truthfully hum-
bly striving to improve ourselves and to be of some honest use.*
—Flora Stone to Samuel Mather, 1881

While abroad, the newlyweds sought experiences that reflected their
commonly held interests in history, literature, and the arts and that spoke
to the compatibility of their union. Their letters to family members and
those they received from them document the blissful couple's honey-
moon. They also reveal the nature and quality of their blended familial
relationships and their significance for Samuel and Flora Stone Mather in
the life they would resume after their seven-month sojourn.

[November 2, 1881]
London

My dear Mrs. Mather [Elizabeth Gwinn Mather]:

This is our anniversary. Sam & I have been married two weeks
today, & if you could have seen us sipping our tea last evening, or
taking our lazy breakfast this morning you would certainly have
thought we were doing the play of "A Happy Pair" very well.

[November 10, 1881]
Paris

Dearest Father [Samuel Livingston Mather]:

Yesterday our hearts were made glad by the receipt of letters from home. . . .

Flora and I enjoyed immensely our 3 days in Rouen, and explored the town thoroughly, having time to see and linger over its splendid monuments of medieval architecture. . . .

We left for Paris at 2 o'clock on Tuesday, and are at the Hotel de Hollande on Rue de La Paris, just off the Boulevard. We have 3 nice little rooms, a small parlor, & 2 Bedrooms, one of which we use for a trunk room & dressing room.

In the evening we went to the Grand Opera House to hear "The Prophet."

Flora is now waiting for me to go out to lunch with her. We take meals anywhere we please, sometimes at the Hotel & sometimes at cafés & restaurants. Today we dine in our rooms and have told the Hotel people to get us up a good french dinner—leaving it to them.

We are both well and enjoying everything immensely. Flora must have gained several pounds since we landed. She has a splendid appetite.

[December 24, 1881]
Cannes

My dear Mother [Elizabeth Gwinn Mather]:

"Tis the day before Xmas" and the sun shines down brightly & warmly upon merry groups of children romping about in the garden among the roses and heliotropes. I have just come up from there myself. A few of us have been sitting under a beautiful date palm, without wraps, the ladies even without hats.

Flora is in town, shopping, she said. She did not want me around, bothering her, and would not let me walk any further with her than to the first shop; whence she bade me be gone and so I came back to the date palm aforesaid. I have, however, an idea that this seeming harshness of hers is only a cloak to conceal an arrangement for an interview with Santa Claus to which I do not object.

We think of you all at home, today, doing the last of your shopping and finishing the decorating of old Trinity.[1]

Meanwhile, at home on Euclid Avenue, the family claim of Amasa and Julia Gleason Stone on Flora was evident even after their daughter's mar-

riage to Samuel Mather. Julia wrote poignantly to a honeymooning Flora on the Sunday following the wedding: "The marriage service struck me the other evening as it has never done before. When Dr. Mitchell said who giveth this woman away, I felt like holding father back and saying no you must not do it. The idea of giving a daughter away was dreadful and although you are going farther and farther each day from me you cannot go where a mother's love cannot reach you and I shall ever claim you as my own dear daughter."[2] Similarly, the patriarchal relationship between Amasa Stone and his daughter prevailed. Just as he had a house built for John Hay and Clara Stone Hay next door to his Euclid Avenue residence, his wishes would also determine the residence of Samuel and Flora Stone Mather. Sam and Flora learned of Amasa's plans while they were in Europe.

> [January 12, 1882]
> Mentone, Hotel D'Italie

Dear Father:

I had a letter from Mr. Stone a few days ago in which he said "please let me know whether on your return you will take up your quarters, with *which we will be very glad to have you do.*" The understanding is his. I replied today, thanking him very sincerely, but saying that "it has always been my desire to have a little home of my own—in which I find Flora sympathizes with me and shares in." Therefore "that I can only say at present, in reply to your very kind invitation that we will be pleased to spend next summer with you in which time I hope to be able to find a home, suitable to my means, in such proximity to both our homes as will enable us to be in & out, daily." I answered thus because Flora said her Father's words mean a desire for us to live with them indefinitely as long as they lived.[3]

A high point of the newlyweds' trip was their visit to Sorrento, Italy, where Sam's aunt lived. Constance Fenimore Woolson (1840–1894) lived close by in Cleveland during Sam and Kate's childhood. After the premature death of their mother, Conny, as they affectionately called her, maintained a strong maternal presence in their lives. Woolson, a short story and features writer of considerable fame in the United States in the late nineteenth century, had moved to Europe in 1879.[4] In a charming and eloquent letter to Kate from Sorrento, Conny reports on meeting Flora and on her deep affection for her nephew and his new bride.

[March 2, 1882]

Hotel Bristol, Sorrento, Italy

My dear Kate:

It happened quite provokingly that during the two weeks Sam & Flora were here, we had our coldest weather for Sorrento. I suppose [they] are so congenial, & so perfectly happy in each other, that perhaps the dullness of Sorrento did not trouble them.

I think Sam is quite a good deal changed since I said good-by to him at New York. He has broadened out generally, looks a good deal older. He was the same dear good nephew to me that he has always been, & while he was here, I quite stopped taking care of myself, & rested in the very fact that he *was* here. While Sam and Flora were here, I leaned back in an easy chair & laughed and enjoyed everything.

They took a parlor next to me & had their meals served there—in which I joined table. But Sam had made his arrangements before I knew of his intention; & to tell the truth, it *was* so much pleasanter that I was very glad to have it so.

You do not know how charmed I am with my new niece. I have always thought her very agreeable—as I presume you remember. But now that I have seen more of her, I think her brilliant, & not only that but very lovable and winning too. I do not know when I have heard anyone talk so well—and all without the least attempt—just in an easy natural way. She told a number of the best sort of stories, & in the way that is so delightful to me—I mean leaving out the unimportant details with which so many people will persist in clogging a story, & thus tiring you out before the point comes.

The point is that Flora—in addition to my natural interest in her as Sam's wife—was perfectly delightful to me in herself. I have met no lady so agreeable in many years. (I was going to say "girl"—for so she seems to me; but you young people are always so indignant when I let you see how grateful you are in my estimation.)

I quite reveled too in all Flora's pretty things—beginning with her cloak, & ending with the little sewing case you gave her. That cloak is superb—isn't it? Alas the velvet dress. I quite insisted upon seeing everything, & she read me the list of her presents, & described them, so that on the whole I at least feel as though I knew something about

my nephew's wedding. The ring Sam gave her, I greatly admire; it is a beautiful gem. Of course the bracelet I still only know from description. I have a great taste for nice things, although I don't know much about fashions, shopping & dressmakers; I enjoyed all Flora's things almost as much as though they had been my own. Sam showed me, by the way, the very nice dressing-gown you gave him. It is a beautiful piece of cloth, I think.

. . . By the way—why did no one ever tell me that Flora sang? I think she has a remarkably sweet voice; not powerful, but very agreeable. She sang some of the "Palestine" songs for me. She'd not like it that I am speaking of her voice. Her own idea seems to be that she can't sing at all.[5]

Sam's letter to his father on Easter Sunday marks the denouement for the honeymooners as they feel called to return home. The question of where they were to reside had grown increasingly complicated in their absence.

<div style="text-align:right">

[April 9, 1882]
Easter Sunday
Seville

</div>

My dear Father:

We think it is best to come home. Col. & Mrs. Hay have written Flora that they intend going abroad in June, if nothing prevents, & would be glad to have us take their house during their absence.

Flora had written her mother, as I had to Mr. Stone, that we would come there for the summer (if we came home, which, at that time, we had not determined upon) but as Mrs. Stone seems to think it would be advisable, it is probable that it will result in our going into the Hay House for the summer.

I would suggest not speaking about it, as Flora wrote Mrs. Hay at first telling her that we had already promised to come to Mr. Stone's and it stands just that way now.[6]

Upon their return from their honeymoon at the end of May, Samuel and Flora Stone Mather resided with her parents at 514 Euclid Avenue. While this living arrangement had been discussed in letters exchanged by Sam with his father and father-in-law, the resolution was likely influenced

by news that Flora was expecting her first child. She was thirty years old when, on August 22, 1882, Samuel Livingston Mather was born. Named for Sam's father, the proud parents called their newborn Livingston.

With the creation of their own new family, they assumed their places in the generational line of Euclid Avenue and new roles and responsibilites. While Sam returned to his familiar and demanding business life, Flora embraced motherhood.

When Flora Stone and Samuel Mather married, a philanthropic partnership emerged, one strongly influenced by the tradition and patterns of giving established within the Stone household. Flora continued her devoted loyalty to her own Old Stone First Presbyterian Church and also regularly attended Old Trinity with Sam, sharing his love and devotion to the Episcopal Communion and appreciating the center of the Mather family philanthropy.

In the century's postbellum period, college endowments of sizable proportions were generated by the rewards of the Industrial Revolution. "One by one colleges and universities found their millionaires or hoped to find them. The significance of these and similar benefactions was measurable in endowment, plant expansion, new departments, new professional schools. What was not measurable altogether was the extent to which the benefactors modified the life of the institutions themselves. Inevitably they found their way to college governing boards and there helped to insinuate many practices that they had learned in their roles as entrepreneurs."[7]

Amasa Stone personified this model of the nineteenth century's big giver. Stone, powerfully built, competitive, aggressive, and domineering, was the archetypal nineteenth-century business tycoon whose life was underscored by struggle, achievement, and exercise of power. Like Vanderbilt and Rockefeller, ambition was his companion. In 1880 he became the major benefactor of Western Reserve College, giving the institution $500,000 to make the move from Hudson to Cleveland ($350,000 to an endowment and $150,000 toward buildings).

Stone's gift carried with it certain conditions: others would provide the land for the relocated institution, the board of trustees would come under his control, and he would bestow on the college a new name. Contributions of $100,000 purchased forty-three acres of land to serve as a campus for both Western Reserve and the Case School of Applied Science, which

had opened in 1881 in downtown Cleveland and was also looking to relocate. Retaining only eight of its original trustees, Stone named eleven men to the board, among them John Hay, retired U.S. president Rutherford B. Hayes, and his recently inaugurated successor, James A. Garfield. The land acquired, Stone took command of its distribution between the two institutions and supervised building construction. On the day of its dedication, October 26, 1882, the college was named Adelbert, after Amasa Stone's only son.

Case Western Reserve University historiographer C. H. Cramer questioned the legend that Stone's contribution was primarily a memorial to his son.[8] Cramer suggested that in the many years that had elapsed since the death of Adelbert, Stone had made charitable gifts to several Cleveland institutions, but none to education. He had not responded to Western Reserve University president Henry Lawrence Hitchcock's personal request for financial support, as had many of his business associates. So why, suddenly, in 1880, was Amasa Stone ready to make his dramatic move? Cramer posits that a rivalry with the Case family and penance for a disaster blamed on Stone motivated his benefaction. Leonard Case Jr. and Stone had fallen out over a business transaction, in which Case accused Stone of dishonesty. In 1880, Case's gift of $1 million for the school that took his name aroused the competitive instincts of Amasa Stone, who increased his gift from $100,000 to $500,000 to Western Reserve. He wanted to name the school Stone, but his association with a recent disaster at Ashtabula discouraged this and he settled for his son's name as a second choice.

Amasa Stone had launched his career as a bridge builder with the wooden Howe truss. As president of the Lake Shore Railroad between Buffalo and Cleveland, he directed its route across a gorge at Ashtabula and ordered an iron bridge built that used an adaptation of the Howe truss. Designed for wooden bridges, the Howe pattern proved unsatisfactory for iron ones. Although the structure served for thirteen years, it failed tragically on December 29, 1876. During a fierce snowstorm, a train was crossing when the bridge collapsed, taking eleven cars with 159 passengers and the crew to their deaths in the chasm below. A legislative inquiry exposed the lack of compliance with safe engineering principles as the cause of the structure's breakage. The blame was laid upon Amasa Stone, whose name, according to Cramer, "became anathema throughout the United States." This attack on his integrity as a craftsman and the

agony of being viewed as a murderer, many claimed, motivated Stone to atonement; hence his gifts to Western Reserve University.[9]

At the dedication of Adelbert College of Western Reserve University, Amasa Stone officially presented the title deed to the premises to President Cutler and the board of trustees. He acknowledged the fifty-three donors of the land who, together with himself, had "appreciated the high and honorable status of the Western Reserve College" and undertaken the task of conveying it to Cleveland, where it was hoped "its sphere of usefulness would be much enlarged and carried as an educational institution to as high a standard as any in this broad land."

In his acceptance, President Cutler dedicated to God the endowment, the ample grounds, and the noble buildings Amasa Stone had raised with "so much loving care in memory of one who was suddenly called away from life with all the high hopes which centered in him unaccomplished."[10]

Amasa Stone was not a well man. For years he suffered from dyspepsia, hypertension, and insomnia, further complicated by an extreme case of eczema. His ailments could be attributed to a lifetime of toil and anguish. Several events exacerbated his condition; among them were the death of his son, the calamitous Ashtabula bridge tragedy, a crippling carriage accident, and in the last year of his life, a series of financial reverses with companies where he was invested.

On April 21, 1883, Amasa Stone wrote to John Hay, who, for reasons of poor health, was traveling abroad with his family: "It seems your family is suffering with colds, which I much regret. As to myself you specially enquired about, I cannot give you encouragement. I have not been to my office for some time. Nervous frustration seemed to be my first misfortune and sleeplessness has followed from then until now. Indigestion & constipation are my companions, besides, therefore my condition is not a cheerful one."[11] On April 26, 1883, Julia wrote Clara, who was worriedly preparing her family to embark for home with hopes of reaching her ailing father:

> I have been praying and trusting that father would be so much im-
> proved that he would telegraph you to remain. I am very sorry that
> you should miss the pleasure of your stay in England this summer,
> but especially, do I regret that Col. Hay could not have had his year
> of rest that he anticipated. . . . Father is certainly more comfortable
> than he was a week ago—and I hope is really better—but he thinks

he is not. The weather is cold and disagreeable. Night before last there was a heavy frost. Flora writes from Atlantic City that it is cold and wet. I hoped that if the weather was good Father might think he could go to New York to meet you—but you must not expect us.[12]

On Friday morning, May 11, 1883, after a sleepless night, Amasa Stone remained in his bedroom. Around noon, he was overcome by profound depression. At 2 o'clock he issued directions to his private secretary, Samuel Raymond, regarding business matters. Then Julia Stone visited his room and urged him to sleep. She checked on him at 4 o'clock and, not finding him in his bed, noted the bathroom door was locked. Calling out to her husband but receiving no reply, she summoned William Axesline, Stone's personal attendant, who climbed through the transom into the bathroom. There in the bathtub, half-dressed, lay Amasa Stone, a bullet through his heart. The weapon, a 32-caliber Smith and Wesson revolver, lay on the floor beside him. Axesline and George Dudgeon, the family coachman, carried Stone to his room and laid him on the bed.

On May 14 Reverend Mitchell of the First Presbyterian Church performed private funeral services, with a stunned, grief-stricken Julia, Flora, and Samuel in attendance. The final interment took place on May 25 at Lake View Cemetery, once the Hays had returned from Europe. The students of Adelbert College sang a hymn, and President Cutler pronounced a final benediction. Julia, Clara, and Flora strewed lilacs and lilies over the casket of Amasa Stone and that of Adelbert, which had been removed to a grave and placed beside that of his sixty-five-year-old father.

Amasa Stone was a private man. He did not give interviews. Instead, he made his statements through the monuments that demonstrated his accomplishments in business and philanthropy. Nevertheless, the public was interested in learning more about him, especially upon his tragic death, and rumors about his lifestyle, wealth, and business practices were rampant. In an interview with a banker who had been an associate of Stone's, a Cleveland newspaper reporter asked,

"Did Amasa Stone's losses amount to much, as compared with his fortune?"

"They footed up a considerable sum, but they were as nothing compared to his possessions. He was a very rich man at the time of his

death. He never, I believe, speculated in stocks or other commodities. When he took hold of any stock he bought it out and out, and never dealt in it on the margin plan."

"Did he keep house in very great style?"

"No. His home, as you have no doubt seen, was elegant and expensive, but he did not keep a large number of servants. His butler and coachman and three or four house servants comprised his help. He had no extravagant habits, and being a man of no great depth of culture as regarded books, he had but little to call his mind from business. He was not a person to set much store by social recreation. His daughter Mrs. Mather is like her father and mother, plain and unassuming, while Mrs. Hay seems to take more to the splendor and elegance which her position and wealth warrant."[13]

Pending the official recording of the document, on June 2, 1883, probate judge Daniel R. Tilden released Amasa Stone's will, and local newspaper accounts informed a very curious public. They reported that he bestowed upon his wife "the full use of my homestead" and all its contents. At the death of Julia, "all premises and estate" he bequeathed "to Flora and her heirs." While he was still living, Amasa Stone had built a house next door to his Euclid Avenue residence for John and Clara Stone Hay. In 1879, Amasa and Julia signed a warranty deed that granted Flora their residence at 514 Euclid Avenue. Amasa wanted to deal with equanimity by providing for both of his daughters.

In addition, Mrs. Stone was granted $500,000 in securities, the interest on which $25,000 yearly would be paid to her in monthly installments. It was stipulated that George Dudgeon, the coachman, and Henry Strange, the gardener, should each receive a house on the estate in return for their faithful service. Daughters Clara and Flora each collected $600,000 in securities, and sons-in-law John Hay and Samuel Mather, each $100,000 in securities. Amasa Stone provided his immediate family and relatives with stocks and bonds totaling $1,900,000 face value. He allotted additional bequests totaling $180,000 in securities to other relatives.

Amasa Stone's provision for charitable institutions was premised on the closing value of his estate at $3.5 million. Adelbert College of Western Reserve University would receive $100,000 to cover the $31,000 cost overruns on the original estimates of the buildings, with the remainder put toward the endowment. The Home for Aged Women on Kennard Street and the

Children's Aid Society on Detroit Street each would receive $10,000 with the proviso that the interest accruing from the principal, which was not to be touched, would be applied only to annual operating expenses.

Stone appointed John Hay and Samuel Mather joint executors of his estate. After debts were paid and bequests totaling $2.2 million were distributed, the remainder of the estate was to go to Clara Stone Hay, Flora Stone Mather, and their husbands to share evenly. Although public estimates ran up to $22 million, Amasa Stone's estate probably amounted to between $6 and $8 million.[14]

In memory of Amasa, the Stone family installed the Amasa Stone Memorial Window in the sanctuary at Old Stone Church in 1885. Famed American artist John LaFarge designed the stained-glass window bearing the inscription "Benevolence" and dedicated "To the Glory of God in Memory of Amasa Stone."[15] The window depicts "The Visitation of Mary to Elizabeth," and the biblical quotation based on Isaiah 1:17 reads: "I delivered the poor and the fatherless and I caused the widow's heart to sing for joy." The objects of Stone's benevolence—women and children—are pictured in the side panels of the window as manifest in his creation of and provisions for the future of the Home for Aged Women and the Children's Aid Society.

After her father's death, Flora Stone Mather became the dispensing hand of a large inheritance, "which as she had not earned, she felt a double duty to distribute wisely and in a way her father would have wished."[16] Flora wrote little about her father's death, but she did reveal her grief in one letter to Sam in the summer of 1883, saying, "When I think of the *business* part of the responsibility that has come on us I simply don't know what *I* should have done without you." With this legacy, Flora chose to continue in the same charitable vein as her father by advocating on behalf of women and children.

In 1884, Western Reserve University was in the throes of an identity crisis. Founded in 1826 in Hudson, Ohio, to educate young men for the ministry, in 1872 it offered education for women. In Cleveland in the 1880s, the growing number of women seeking education at Adelbert alarmed those who held to the mission of a men's college. At his inauguration as president of Western Reserve University on January 24, 1888, Dr. Hiram C. Haydn, pastor of the Old Stone Church, announced the end of coeducation and revealed a new plan: Adelbert College was to be for men only, and a women's college, in close proximity and in every respect equal, would be created.

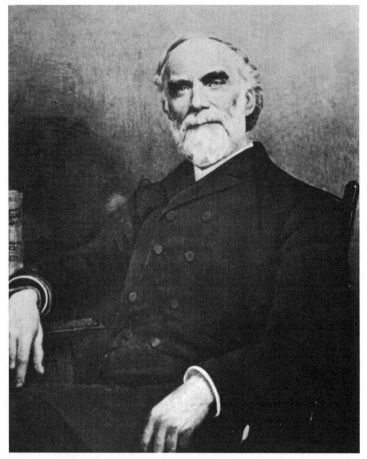

Hiram C. Haydn, pastor of the Old Stone Church and president of Western Reserve University, ca. 1889. Case Western Reserve University Archives

"What shall we do with our daughters?" was the rhetorical question Dr. Haydn put to his congregation three months later. "It is a matter of immediate interest whether our city is to have a college for women," he said. "I know nothing in the way but the cost of it."[17] His parishioners were among Cleveland's wealthiest families, and it was to them he made his appeal for endowments that would sustain the College for Women of Western Reserve University. His particular success was with women who had male models of giving within their families.

Flora Stone Mather was one such woman. Influenced by her own formal

education and empowered by the wealth she inherited, she chose to advance the opportunities for women's higher education through the College for Women of Western Reserve University. Because she inherited from her father the monies she distributed, she felt a double duty to administer them wisely and in a way he would have wished. When she received recognition for her generosity, she would often quietly say, "The praise belongs not to me: I am but the dispensing hand of a Father's bounty."[18]

Following a family tradition of financial support for Western Reserve started by her father, Flora Stone Mather made her first large gift to Adelbert College in 1888 when she contributed $50,000 to endow its first chair of history in the name of Hiram C. Haydn. The first monetary gifts for the College for Women were $5,000 from John Hay and $3,000 from Julia Gleason Stone; these enabled the college to open in rented quarters at the southeast corner of Euclid Avenue and Adelbert.[19] Her brother's name would forever be linked with the men's college—as hers would be with the women's college.

Haydn sought a female support system for the creation of the College for Women. He brought together a group of women knowledgeable and interested in educational matters who constituted the Advisory Council, appointed by the board of trustees, which bore ultimate responsibility for the educational and social conditions of the College for Women. As part of this council, Flora became one of that body of women who, in the spirit of sisterhood, encouraged and fostered "the University's newest child." They sponsored and oversaw the building of the library and furnished the first classrooms of the new college with their own pictures and pieces of furniture, curtains, and other personal articles. Haydn regarded these women leaders as indispensable adjuncts, noting "their constant and intelligent sympathy, wise and beneficent counsel, gifts of time and money, the social prestige of their names, and their personal merits and worth." He celebrated Flora Stone Mather as "most favored of all" for her personal involvement as well as financial investment that were fundamental to the education and social life of the institution.[20]

In the name of her teacher Linda Guilford, Flora Stone Mather contributed $75,000 for building and endowment of the college's first dormitory in 1892. Called Guilford Cottage, it was given "in grateful and loving acknowledgment of the debt which this community owes to her" for the establishment of reputable instructional programs in several academies and

seminaries in Cleveland.[21] And in 1902, the completion of Haydn Hall met the growing college's needs for classrooms—thanks to a $75,000 gift from Flora Stone Mather that honored pastor-educator Hiram C. Haydn.

Certainly Flora Stone Mather gave generously on behalf of the College for Women. But she also gave of herself generously. She was interested in the daily lives of the students and enjoyed being among them, as evidenced in a reminiscence by college alumna Mary Hover Collacott.

When at least twice or perhaps three times a week the door of Guilford House opened to admit Mrs. Mather, any girl who chanced to be near the door impulsively stepped forward to look with level eyes into her bright and expressive ones and to extend her hand to grasp the one which Mrs. Mather so cordially held out to her. She seldom came empty handed. It might be flowers—not thrust forward or laid down indifferently but presented graciously with "I thought these would look well on the mantle" or "wouldn't these be attractive beside that green glass lamp?" on the table in the Guilford drawing room. . . .

Often she took lunch with us[,] refusing the seat of honor next to the faculty member always resident in the house, that she might know better each of the sixteen girls by talking with them informally.

Sometimes she would go to our rooms, never in a spirit of criticism, but to see if something more might not be arranged for our comfort—"Were the lamps as they should be?"

Mrs. Mather was a small woman with black hair whose attractiveness lay largely in her very expressive and kindly eyes. She was frail but seemed to have great nervous energy. Even in our thoughtless youth we used to wonder that she could come to us so often. She was a busy woman, mistress of a large house with a family of young children and she was actively engaged in church and civic affairs. Then too, she lived at a considerable distance and the drive out and back with horses absorbed much time but we were never forgotten.[22]

As Flora expressed in a letter to Western Reserve University president Charles F. Thwing, "I like to cultivate good girls—cultivate isn't the right word—the idea is to help girls to develop and spread wider the circle of light." The giving, however, whether of life or of treasure, represents the highest relationships, for in the same note in which she speaks of her

liking to help girls, she also says: "The loan was not made as a money investment, but as a moral investment."[23]

In addition to her interests in women's education, Flora Stone Mather was a social activist. She was responsive to the problems arising from industrialization and acted on her personal convictions of advocacy for women and children. This activism was evident even at age twenty, when she was an organizer of the Young Ladies Temperance League. She continued her father's financial support of the Children's Aid Society and Home for Aged Women, where she was well known to teachers, children, and the elderly as a friend, counselor, and worker. And she was the first president of the Cleveland Day Nursery and Kindergarten Association of the Young Ladies Branch of the Women's Christian Association. She even gave the former Mather family residence as sanctuary for the Bethlehem Day Nursery.

Shortly before her father's death, Flora had initiated correspondence with former Euclid Avenue resident John D. Rockefeller for support of the Day Nursery and Kindergarten Association: "We have three nurseries under our care and we feel that with our increased experience they ought to increase not only in numbers but in usefulness." Three years later, Flora informed him: "This has been our most successful year, at least so far as the Perkins Nursery is concerned. That is the largest and best appointed in every way, and through the summer we had as many as thirty-eight children some days. Even in the winter weather when the women have less opportunity for obtaining work by the day we have had as many as twenty-seven and eight children a day, all we can manage with our present arrangements." And in 1893 she acknowledged his annual gift: "We are endeavoring to make our kindergartens more effective this year. We feel sure that no influence is stronger in its neighborhood than the ideal kindergarten and we want to approach that ideal as nearly as possible." Her persistence succeeded in securing the tycoon's monetary support of the association for two decades.[24]

Samuel Mather also took on the mantle of philanthropy that his father-in-law had worn. In 1884, at the age of thirty-three, Sam became a trustee of Cleveland City Hospital, an institution Amasa and Julia Stone helped establish in 1863 to assist refugees of the Civil War and, later, Cleveland's poor. Similarly, in the tradition of support for Western Reserve University initiated by Amasa in 1880, Sam began his tenure on the board of trustees. He served both institutions faithfully and generously all his life.

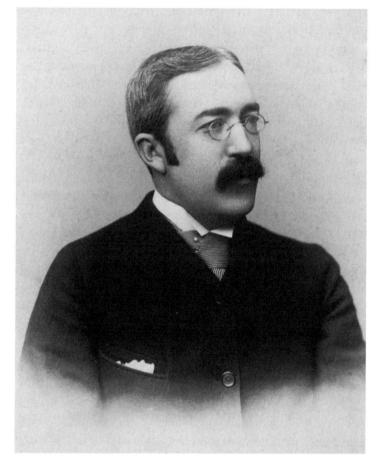

Samuel Mather, head of Pickands Mather & Company and philanthropist, ca. 1884. Western Reserve Historical Society

In September 1882, Sam had traveled to Marquette for what would be a turning point in his career. Early in 1883, Mather withdrew from the management of his father's business but still maintained a financial interest in it. And in Cleveland in the spring of 1883, the partnership of Pickands Mather & Company, dealers in pig iron and iron ore, was announced. The new company had temporary offices in the parlors of the Cleveland Iron Mining Company, and they began with initial interests in two small mines in upper Michigan and a wooden steamer.[25]

By spring 1884, when the shipping season began, Pickands Mather moved into offices of their own, two small rooms in the new Grand Ar-

cade, across from the Kennard House on St. Clair Street. Under Samuel Mather's leadership, the firm became a sales agent in the newly mined iron range of Wisconsin and Minnesota during the 1880s and 1890s. And, to facilitate its business, Pickands Mather began to manage Great Lakes docks and acquire steamship companies. By 1913, all of its vessel companies would be consolidated into the Interlake Steamship Company, the second-largest fleet operating on the Great Lakes.[26]

Despite a busy work and travel schedule, Sam was a devoted husband and father and shared fully in the responsibilities of parenting. In one instance, while Flora accompanied an ailing Julia on a recuperatory trip, he wrote about the children, knowing how much Flora missed them.

Clara came over after breakfast to use the telephone & invite the Raymond children down at 4:00 to a magic Lantern exhibition. . . . Del had a nice time last evening. Ed worked the Magic Lantern successfully and the children all enjoyed it. Alice would call out in the darkness every now & then, Oh Reidy [Miss Reade, the Hay nursemaid] ain't it lovely, or "Oh, ain't it pretty?"

Livingston had another good night, and came in again at 7:15 this A.M. in his high chair, calling "Mama & Papa" very impartially & prettily when I opened the door to let him in. He misses you very much and don't think Papa alone half fills the bill.

Flora replied: "Sunday is apt to be a homesick day if one is *ever* homesick, & I confess to feeling a little forlorn this morning, & so hungry for the baby. What would I not give for a sound of his baby voice & touch of his soft fingers!"[27]

On August 20, 1884, Sam and Flora welcomed their second child, Amasa Stone Mather, named for her father.

Against the backdrop of these events—Sam's new business venture, Amasa's death, and the young couple's philanthropic responsibilities— the letters exchanged by Sam and Flora document their lives, their family, friends, business, duties. While apart, the pair shared every aspect of their lives, detailed in letters that documented a devoted and loving marriage, joyful and concerned parenthood, and a dutiful adherence to "the family claim" that embraced their parents and kin, as expressed in a note from Sam to Flora on October 22, 1884: "Three years ago it was, my darling that we started for Europe. How much in that short time has occurred! It

seems now as though you had been always a part of my life: and the dear boys. What would we do without them now?"[28]

In 1896, Cleveland's centennial year, the city looked much like an over-grown village; cows pastured within a mile of Public Square.[29] Although it did not exhibit the extremes of human needs and distresses of older eastern urban centers, it had its problems.

Patterned on a model that originated in London's Toynbee Hall in 1884 that involved college students taking up residence in poor neighbor-hoods and developing social service programs with and for the people of the area, in 1886 the New York University Settlement opened, followed three years later in 1889 by the College Settlement and Jane Addams's Hull House in Chicago.[30]

In summer of 1895, Lucy Buell, who had been a resident at the College Settlement in New York, introduced her friend Flora Stone Mather to the settlement plan, and Flora began the work of establishing a settlement in connection with the College for Women. In April 1896 she honored her girlhood pastor, William Goodrich, when, a few blocks east of the Old Stone Church, at St. Clair and Bond (East 6th) streets, the foundation was laid for the Goodrich Social Settlement.

Flora generously equipped the Goodrich Social Settlement with a large building that was considerably more elaborate than those of any other American settlements. Gothic in design with Spanish Renaissance detail, Goodrich "House's" walls were brick and terra-cotta and its interior was finished in oak. The first floor had a library, kindergarten, gymnasium, stage, and seating capacity for 300. The second floor housed offices and clubrooms and the third floor the rooms for residents. The basement was reserved for public baths and laundries.

Lucy Buell returned from the College Settlement in New York to serve as one of the first Goodrich residents. At first she was struck by the size and ornateness of the building and worried that it might prove intimidat-ing to the community: "It was with some misgivings that we took posses-sion of our beautiful building." But in February 1897, kindergarten classes began, and by October there were thirty clubs meeting each month with an attendance of 680. After three years, Goodrich House was more than fulfilling the function for which Flora had strived: "to provide social, spiritual, and material betterment for the neighborhood of the Old Stone Church." In March 1900 she presented the deed of the building and land

on which it stood to the trustees. In addition, she gave $10,000 as the first installment of an endowment fund, and thereafter she covered the operating expenses of Goodrich House.[31]

Also in 1896, and close to home, George Bellamy and his fellow students at Hiram College, the liberal arts college southeast of Cleveland in rural Portage County, where James Garfield had served as president (1857–61), in a practical application that grew out of a Bible-class discussion, set about establishing a social settlement—Hiram House—on the west bank of Cleveland's Cuyahoga River. Bellamy and his comrades solicited substantial support for the institution from prominent families, including especially Samuel and Flora Stone Mather. According to one of her contemporaries, "Among the generously disposed women of wealth, Mrs. Mather stood first in the wisdom with which she gave, in the degree in which she gave *herself* and in the rare quality of that personal bestowment with her gifts."[32]

With the dedicated participation of both Flora and Sam, a partnership in philanthropy emerged that had its origins primarily in the Stone family. Amasa and Julia Gleason Stone had been involved with the development of the Cleveland City Hospital from its origins at the First Presbyterian Church in 1863 as the Home for Friendless Strangers; Julia remained a consistent and substantial donor throughout her lifetime. While Samuel Mather's family had made modest donations to the Cleveland City Hospital, it was not until 1883, two years after his marriage to Flora, that he joined her and began a program of financial support for the hospital.

In 1889 the board of the Cleveland City Hospital, of which Sam was a member, changed the name of the privately run hospital to Lakeside Hospital upon their purchase of five acres on Lake Street, between East 12th and East 14th, for the building of a new hospital. In 1898 the new complex began operation, guided by principles advanced by Samuel Mather: the choice of the pavilion plan; pure air and perfect ventilation systems to prevent spread of contagion; a public clinic where medical students worked under teaching physicians; a training school and home for nurses; a dispensary system to provide medical advice and remedies for the sick poor.

Flora continued her family's tradition of support of the older institution and served on Lakeside Hospital's Board of Managers. In 1898, during her tenure, the Lakeside Hospital Training School for nurses opened. Initially, students paid no tuition but took an active part in caring for patients almost as soon as they arrived; indeed, in 1899, the entire nursing staff of the hospital numbered sixty-one, and thirty-five of them were students. In

cooperation with the Visiting Nurses Association and various dispensaries and schools, Lakeside's students were trained in district nursing and the care of outpatients. Flora responded to the need for housing and gave the money to build a nurses' dormitory.[33]

Flora's lifetime involvement with the Presbyterian Church at home and abroad coupled with her catholic interests found her particularly interested in the Ladies Society and the work of the Women's Missionary Society. Flora connected those planning Old Stone's foreign mission in Vengurle, India, with medical missionaries Dr. and Mrs. Robert H. H. Goheen. The Goheens credited the mission's survival to her faithful financial and moral support.

The creation of missions—at home and abroad—became one of Flora's paramount concerns. She embraced Cleveland's North Congregational Church and Antioch Baptist's black congregation. She supported Francis Goodrich's work among the mountaineers of North Carolina and Robert Speer's venture in the southern United States with the freedpeople. Her substantial gift also helped build quarters for the Young Men's Christian Association in Shanghai. Similarly, many of Flora's benefactions for higher education were church related. Beyond the College for Women, she also supported the Presbyterian affiliates College of Wooster and Buena Vista College (Iowa); the Episcopal Kenyon College; Lake Erie College for Women, alma mater of Hiram Haydn's daughter Elizabeth; and the black colleges Wilberforce (Ohio), University of Atlanta, and Livingstone (North Carolina).[34]

In the years bridging the nineteenth and twentieth centuries, and parallel with her expanding philanthropic responsibilities, Flora Stone Mather maintained a life centered on her husband and children, the Stone and Mather family members, and her circle of friends. She remained constant in fulfilling her roles as a daughter, sister, wife, and mother, seeking greater self-knowledge in order to offer more to those with whom she had treasured relationships.

Characteristic of their relationship, the communications—letters, telegrams, and telephone calls—exchanged by Flora and Samuel Mather revealed their abiding partnership. They shared parental responsibility for the physical, intellectual, and moral development of their children. They discussed financial matters surrounding Sam's rise to preeminence in the iron ore industry. And together they managed Flora Stone Mather's fortune in fulfillment of her commitment to philanthropy.

Flora Stone Mather with sons Amasa and Livingston, ca. 1885. Western Reserve Historical Society

Flora was devoted to her children. Whether she was at home in Cleveland or away vacationing with her mother, her concerns for them were foremost. She responded with intelligence and sensitivity to each child in matters of health, education, religion, and personal development, as seen in a letter she wrote Sam about their sons:

You will understand better what I mean by considering the two boys. Don't you remember how Amasa's love for Kate showed itself in his looks & words & whole manner, & don't you know, when you've been talking very gently with Livingston how hard it was to get any expression of affection–the effort embarrassed him? Yet sometimes when he has been naughty & wants to let me know he is sorry & does love me his effort to express his feeling is pathetic; it is so very difficult for him.[35]

While at the The Fells, the Hays' summer home in New Hampshire, where Flora was vacationing with her children, she described for Sam an industrious Livingston: "The money making mania is on him now & he has been faithfully chopping & sawing wood for the fire all day, nearly. He has been very good about putting in his stamps the last few days."[36] The family did vacation together, too. To escape the heat of the city, Sam and Flora and the children spent summers at Shoreby, the twenty-five-room suburban home on Lake Erie (in what is now Bratenahl) that architect Charles F. Schweinfurth designed and built for them.

Flora was thirty-seven years old when, on September 21, 1889, her third child, daughter Constance, was born. Sam and Flora named her in honor of Constance Fenimore Woolson, Aunt Conny.

In the cycle of generations, with the death of Samuel Livingston Mather on October 8, 1890, at age seventy-three, Samuel, senior partner of the now hugely successful Pickands Mather & Company, was now hailed as Ohio's wealthiest citizen.

This loss of his father was followed in early 1894 when Samuel Mather received shattering news about the death of his beloved Aunt Conny from Grace Carter, a Woolson relative. In a lengthy letter to Sam, Grace detailed the events leading up to and following her arrival prompted by a telegram from Constance that said, "Am worse. Come. Grand Hotel near my home." Grace went immediately to her residence, where, she writes, "I was met with the news of Cousin Constance's death" early in the morning of January 24, 1894. "In the absence of other relatives they had waited for my coming." Grace Carter took responsibility to gather information about the circumstances surrounding Constance's death from a fall through an open window, a probable suicide judged drug induced and depression related.[37]

Later that spring there was happier news: at age forty-two, Flora gave birth to her fourth child, Philip Richard, on May 5, 1894. Samuel's aunt Mary L. Mather sent the family her congratulations:

[May 24, 1894]
Marquette

Dear Flora and Sam:

A letter from Kate which came yesterday brought the good news that you had another dear little boy, and that you dear Flora were doing very well, which is cause for great thankfulness to all who love you, particularly to your husband and children, and your Mother.

How happy you must all be now with another dear little soul to love and watch over, for it seems to me you are both particularly fitted to bring up a little family.

Mrs. White and I have often spoken of how interested and united you seemed in regard to the children.

How lovely for the baby to have two such brothers as Livingston and Amasa to look up to, and a dear little sister Constance.[38]

That summer Sam spent time with Livingston and Amasa and introduced them to the Mather family enterprise on an excursion across Lake Erie between Cleveland and Detroit. On July 30, 1894, twelve-year-old Livingston wrote his mother about their experience on board the *Mauritania:*

Dear Mamma

We had a very nice time last night, and did not feel seasick at all.

I think the Maritana is awfully nice[,] the captain is so nice[,] and Gordon the man Papa hired from the Weddell House. We passed the D. I. Witney towing the Wayne. There is another boat in sight now[.] I will tell you it's name when it gets near enough. The Boats name is Chase Stewart Cornell. Please tell Constance that I will write her soon and tell her to do the same. Write Soon.

Your loving Son,
Livingston.[39]

A photograph of Flora with Constance and Philip taken just two years later, in 1896, revealed Flora's growing fragility. The physical and emotional demands of bearing and raising four children, managing a household, and fulfilling her philanthropic commitments were taking their toll. Even though Sam and Flora shared parenting responsibilities, the demands of his business kept him away from home, leaving the oversight of home matters to her.

Flora Stone Mather with Philip and Constance in 1896. Western Reserve Historical Society

Even before Philip's birth, Flora Stone Mather confided in and consulted with her dear friends and confidants, her former teacher Linda Guilford and her pastor Hiram C. Haydn, about her children and family responsibilities, revealing her keen awareness of her own limitations.

[July 4, 1891]
Shoreby

It *is* true, what you say, that my greatest gift to the next century

would be my *well trained* children. I say would be, for this responsibility (that is the wrong word there) is so much more difficult than anything else that I sometimes cry out that I cannot do it, it is so much for me—but then I think—What if I should give it up. What if the Lord should take me at my word? And then I begin again to try & discipline myself to discipline them with patient love.

Giving is such a cheap, easy virtue, a sort of penance, to quiet one's conscience. Character is the great thing, isn't it? But in this matter of possession, Miss Guilford, you know I have a double duty. I want to do, as Father would wish with what he left me.

And as for outside work, I believe I have learned a lesson & I won't try to put a finger in every pie that's baking. Certainly it is most unsatisfactory as far as oneself is concerned & it is equally so as regards really good results in the work one cares for; one can't be *thorough* if one spreads oneself too thin.[40]

Hiram C. Haydn acknowledged that her "mother-love of course covered a wide field, but the Sunday afternoon hour with her children, and frequent conversations with me how best to use these opportunities, how wisely to express her concern for their religious welfare, and interest them in bible truth, reveal where the heart was centered." Her daughter, Constance, also confirmed her mother's determination to provide a rich educational and religious environment and acknowledged that she could not always accomplish everything she would have liked to do, the same frustration Flora herself had expressed to Guilford and Haydn:

> [Mother] was a student of Biblical literature, always searching the best commentators. Both parents read aloud often, and well,—and how we used to enjoy Biblical Twenty Question games on Sunday night! All good literature interested them, including particularly history, biography, art, essays, travel and current events. Mother's days were all too short for the reading she wanted to do.

She also pointed to the logical outcome of the generosity of Samuel and Flora Stone Mather: "They were actively interested in developing and enriching the schools which their sons and daughter attended."[41]

The devoted interest of Samuel and Flora in their children's education manifested itself in developing and enriching schools that their sons

and daughter attended, University School and Hathaway Brown. In 1890, University School,[42] a private preparatory school for boys, opened its doors thanks to the support of Samuel Mather as well as several other prominent Clevelanders. The country day school included primary through senior-level grades. Designed on the classical model, with its emphasis on training the mind, it also recognized the rapid development of industry and entrepreneurship and offered students practical preparation for careers in business and industry through experiential education. In addition to traditional classrooms, the school contained a machine shop, a forge, carpentry shops, a swimming pool, and a gymnasium.

Hathaway Brown was located at 770 Euclid Avenue when Constance Mather attended it, just a short distance from her home. At the turn of the century, Euclid Avenue families found their neighborhood was changing. In an effort to escape its increasingly commercial character, they moved eastward, seeking new residential areas. Similarly came the need to move Hathaway Brown School. Principal Cora E. Canfield turned to Flora Stone Mather, whom she knew as a foremost proponent of women's education and as the mother of a Hathaway Brown student keenly interested in her daughter's education. Flora Stone Mather responded; there was a clear intersection of their philosophies. As stated in their catalog: "The Hathaway-Brown School aims to cultivate concentration and systematic, scholarly habits, to promote a happy natural development of all faculties, to encourage creative power and to inspire ideals of service." In 1901 Hathaway Brown instituted the "Order of Willing Service," which provided students with the tools for effective community involvement in fulfillment of the school's motto—*Non Scholae sed Vitae Discimus,* "We learn not for school but for life."[43]

Flora's appreciation for all that Hathaway Brown had accomplished with Constance was returned in kind by a teacher who acknowledged the importance of the positive influence Constance had at home: "Constance has been a growing pleasure and comfort. . . . I shall expect very fine things of her. She has many noble traits, and a mind of unusual power. Her faults, it has seemed to me, she has been outgrowing steadily. I cannot see how it would be possible for her to be anything but an admirable woman with such home influences as she has."[44]

Determined to chart her own course of philanthropy, Flora worked actively to build institutions that would thrive and make a difference. Her advocacy on behalf of women's education was expressed in the creation of the College for Women of Western Reserve University.[45] In a further

demonstration of her leadership and contribution to the educational life in Cleveland, she was called to exercise her extraordinary leadership skills in the advancement of Hathaway Brown School.

In March 1904, Flora Stone Mather issued an invitation to parents of Hathaway Brown students to come to her Euclid Avenue home for an organizational meeting that led to the creation of the East End School Association. "I cannot take a laboring oar, but I will give some money and my influence and assistance," she said. The goal of this group was to provide a new building for Hathaway Brown, moving the school east from its downtown 770 Euclid Avenue location to the less urban East 97th Street. Flora gave $33,000 for the land, and Samuel advanced $10,000 toward the building. The groundbreaking for the new school took place on September 27, 1905.[46]

Flora received numerous letters from Hathaway Brown students, faculty, and alumnae thanking her. Leslie Clark, secretary of the Alumnae Association, wrote of the "deep appreciation we feel for the interest which you have so unrestrainedly taken in our school and for the generosity which has made possible our fine new building." One letter writer, Mary Kline, also on behalf of the Alumnae Association, asked: "Would it be too much to ask of you to consider calling the new school the 'Mather School'? It is the earnest and sincere wish of the members of the Association that this change be made, and we all hope that you will be willing to have your name given to the school."[47] As was her custom, Flora refused such public recognition for her philanthropic efforts.

On April 15, 1907, dubbed Moving Day, Hathaway Brown School pupils of all ages left their Euclid Avenue address. Arriving by streetcar and automobile, bearing bundles of books, the young ladies trooped into their new building at 1945 East 97th Street. Bishop William A. Leonard led the invocation and the formal dedicatory services attended by the students as well as trustees, parents, and faculty; and, in words that coincided with Flora's beliefs about educating young women, Rev. Dr. James A. Williamson delivered an address in which he voiced the purpose of the school and emphatically declared that Hathaway Brown was not "a fashionable school for girls." Its purpose was to "train our developing girls into ideal women, and while we wish to lay proper stress on the knowledge to be obtained by books, . . . we must never forget that there are other things still more important."[48] And just a short two months later, on June 6, 1907, Samuel and Flora attended the closing exercise of Hathaway Brown

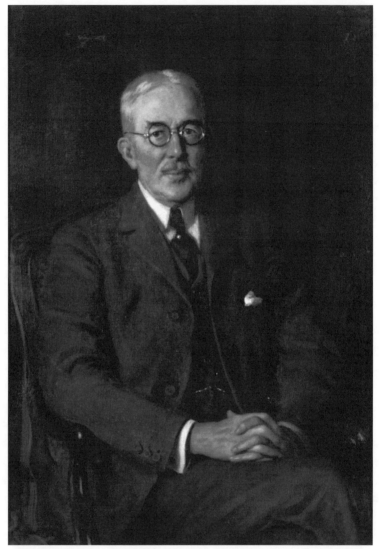

Samuel Mather, *by Ellen Emmet Rand, oil painting, 1907, hangs in the Lakeside Lobby, University Hospitals of Cleveland*

School and witnessed the graduation of their seventeen-year-old daughter, Constance.

As a philanthropist, Flora provided funding for the physical plants, served on the governing boards in a leadership position, and engaged with the clients as a regular volunteer. Her selfless dedication and involvement in every aspect of the lives of the institutions characterized her contribu-

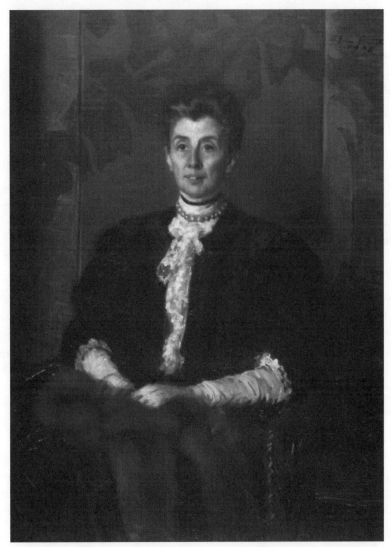

Flora Stone Mather, *by Ellen Emmet Rand, oil painting, 1907, hangs in the Flora Stone Mather Reading Room, Kelvin Smith Library, Case Western Reserve University*

tions and her unique perspective. Whether at home or vacationing, Flora followed closely those events that involved her philanthropic commitments. Among these responsibilities was the Women's Advisory Council of the College for Women, which she served as president from 1895 to 1898. When she was in Florida in February 1896, likely accompanying her mother on a recuperative trip, Flora learned from Sam about some

important developments at the College for Women. Anna M. Richardson Harkness and her son-in-law Louis Henry Severance, in memory of her daughter Florence (1864–1895), funded the Florence M. Richardson Harkness Chapel on the campus of the College for Women. This considerable gift followed that, years earlier, of Mrs. Elizabeth Ann Clark (widow of James F. Clark), who built and endowed a building for classrooms and a library.[49] Flora's tireless work on behalf of the College for Women was bearing great fruit.

In addition to her roles of philanthropist and mother, Flora respectfully and lovingly fulfilled her role as a daughter. And after her father's death, she became her mother's companion. So it was a great loss for Flora when, on July 21, 1900, eighty-one-year-old Julia Ann Gleason Stone died from pulmonary tuberculosis. The funeral service was held at the Mather home on Tuesday, July 24, and was followed by private burial at Lake View Cemetery.[50] There the former Massachusetts seamstress was laid to rest beside her husband, Amasa Stone. There, too, lay her son, Adelbert. Ever the center of tender concern for her daughters, Clara and especially Flora, Julia Gleason Stone was revered as an exemplary model of wifehood and motherhood. Her monument bears the epitaph, "Love is the fulfilling of the law."

1903–1909

It is true, *what you say, that my greatest gift to the next century would be my* well trained *children. I say would be, for this responsibility (that is the wrong word there) is so much more difficult than anything else that I sometimes cry out that I cannot do it, it is so much for me—but then I think—What if I should give it up. What if the Lord should take me at my word? And then I begin again to try & discipline myself to discipline them with patient love.*
—*Flora Stone Mather to Linda Guilford, 1891*

Travel abroad was an essential ingredient of Euclid Avenue family life, and experienced parents introduced their children to international excursions. During the early years of the new century, the Mather clan enjoyed several trips to Europe. The whole family spent the summer of 1903 abroad, in London, Lucerne, Cannes, and Milan, and Flora wrote letters home detailing how much the "boys" (now young men) and Constance were enjoying the outdoors and expressing how exhilarated she was—"Just at this instant it seems to me that we are enjoying all the best that this world has to give. The air is so tonic that we all feel as fresh as daisies after our walk this morning."[1]

Flora's friend and pastor Hiram C. Haydn observed that as her children grew older and more independent, Flora's public duties broadened and deepened, until, in later years, they became absorbing. Fond as she was of her friends and society, as her interest in missions, the church, and work

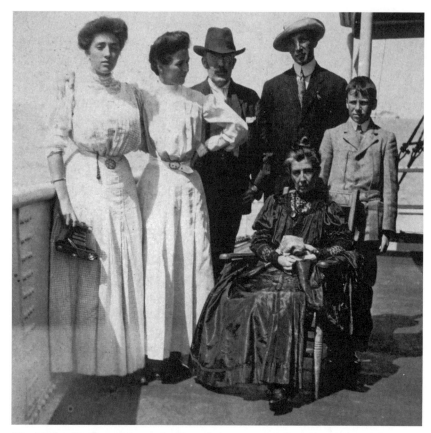

The Mather family cruising on the Great Lakes, ca. 1906. Standing, left to right: *un-identified woman, Constance, Sam, Amasa, Philip, with Flora seated. Western Reserve Historical Society*

for social betterment grew, she largely withdrew from social functions. She had not time or strength for both, and the more important left little time for the less consequential. Haydn attributed this choice to "the intelligent interest she cultivated in the movements that are shaping our age—and her knowledge of the men and women who are the wise and forceful leaders of them."[2]

Flora's focus on family was also increasingly important, evident in particular when her sister, Clara, faced first the loss of her son, Del, in 1901 and then her husband, John, four years later, on July 1, 1905. Hay, aged sixty-six, had been diagnosed with heart-related ailments earlier in the year and never fully recovered. He was buried on July 5 in Cleveland's

Lake View Cemetery. Ever the dutiful son-in-law, John Hay toiled in
Amasa Stone's world of business, which did not really suit him, a man
of letters. Yet once here, in the tradition of his father-in-law, he served
Western Reserve University on the Board of Trustees of Adelbert College
and the building committees that erected the two original structures on
the campus. On July 5 Clara placed a final entry in her husband's diary:

> The funeral was arranged for today. The services were held at the
> Wade Memorial Chapel at Lake View Cemetery. President Roose-
> velt and all his cabinet but Mr. Taft, who was on the way to the Phil-
> ippines, with the gentlemen who had been members of the cabinet
> met at the Chamber of Commerce and escorted by Troop A went
> to the cemetery. The services were very simple—conducted by Dr.
> Haydn and Dr. Meldrum and the chapel was full of friends. The
> floral tributes at the grave were very numerous and beautiful. The
> service there was all very simple and I could not realize that it was
> he who was being lowered from my sight. All signs of death were
> concealed and nothing to show that it was the end. It was terrible. I
> cannot yet realize what has happened. I am paralyzed and numb. I
> suppose I will wake up some day and will know.[3]

The year 1906 opened with another European tour—this time by
steamer, but only for Flora and Samuel and their eleven-year-old son,
University School student Philip, "Phid," and his nurse-companion, El-
len. Sixteen-year-old Constance, "Con," was a boarding student for her
junior year at Hathaway Brown School; Livingston, "Liv," had graduated
from Yale in June of 1905 and at twenty-three was at work for Cleveland
Cliffs in the iron-ore mining department in Ishpeming; and Amasa, "Am,"
twenty-one, was completing his senior year at Yale. The correspondence
between and among parents, children, and family members brings to-
gether all the actors in a deeply personal and engaging family drama.

In letters to her daughter, Flora remained constant in her mother's
role, with words of appreciation for her messages, approval of education-
al accomplishments, and admonishments about the need for fashionable
party dresses. She interspersed details of their travels with tender words
about how much she was missed.

[February 12, 1906]

On Board Amerika Linie Moltke, in the harbor of Gibraltar

My dearest Constance:

This is my first letter to you, but as your father has written, I will begin first by answering the questions in your steamer letter. It was a *very* nice letter, & the one to Philip was as bright & amusing as possible.

I was glad to know that you got 95 in history test. If all your Fridays & Saturdays are like your first I wonder if you will get it again or *pass* Latin. Lunch Friday, Friday evening dancing class, Saturday evening Basket ball game. However, I am not going to talk about that. That rests wholly with you. It was nice of John Dempsey to ask you to go to the basket ball game, but of course you were quite right not to accept.

It seems to *me* best for you to keep up your lessons with Mrs. Ford twice a week. You know you do not practice at all (unless you have begun since I left) & unless you have at least two lessons a week you will get into very bad habits. I am wondering if your suggestion of one lesson is an indication of loss of interest. I sincerely hope not, for I do feel that if you really *tried* you could make a very agreeable singer.

As I recollect it you did not need another *evening* dress. For real parties you can probably use your Raymond bridesmaid dress at least once more. If you have ordered nothing yet, don't do so, for Helen Hay says Reilly has such pretty simple dresses of white linen that they call *tennis dresses*. I will look at them when I return in June & by that time you will know if you really do need another thin afternoon dress. You said *evening* dress, but to my mind that means a party dress.

[February 17, 1906]

Moltke

My dear Constance:

We were very much interested in our brief glimpses of oriental life at Tangier & Algiers. At Algiers yesterday Philip said, when we were going through the Arab quarter, "If you are going to do any more of this sort of thing please leave *me* out—" but yesterday it was much cleaner & less odorous than Tangier.

The other day Philip said—"This is Valentine's Day—& I don't believe a single person on this boat has had a valentine." I don't believe a day has passed since we left home that Philip has not in some way showed his regret that you were left at home. Ellen says he has shed a good many tears on your account, but I've not happened to see him crying, for myself. I find that often as I have wished to see you I have *quite* often said to myself—"I'm glad Constance isn't here now. She wouldn't like this or that." But we do think of you & talk of you a good deal, Daughter dear, & we are often saying, "When we come again with the children we will do so & so."

> [March 6, 1906]
> Cairo

Dear Con:

While waiting at this bank to get some money I will write you a few lines.

The Pyramids were about as interesting as any one thing, but the Museum is quite as much as, for it contains objects of the greatest value and interest from all the monuments, temples and tombs of that Old, Old Egypt which everybody loves to know more about.

Jewelry, too, obtained from the tombs of Pharaohs and wives of Pharaohs who died 3000 or 4000 or perhaps 5000 years ago. I have bought for you an exact imitation of a lovely bracelet which belonged to "Queen Ashtoreth[,]" the original being in the museum where I saw it only this morning!

But the streets of Cairo are as interesting as anything else, crowded with Turks, Egyptians, Copts, Nubians, Ethiopians, Armenians, Jews, French, Russians, Persians, Americans; all sorts of people in all sorts of dresses & wagons, while camels and donkeys and horses & pedestrians, all mingle together in great confusion to our great delight.

> Your loving Father[4]

But the tone of the letters changed when, from Rome, Sam wrote that Flora was ill. For the remainder of their trip, until their return to America in early June, Flora was unwell, and the travel plans were changed to accommodate her poor health.

[April 15, 1906, Easter Day]
Grand Hotel–Rome

Dear Constance:

Your Mother has been in bed all day. We did not intend to speak of her illness at first, for Dr. Baldwin who came in to see her first Thursday morning said it was only a sight sore throat with some fatigue, and that she would certainly be all right in a day or two. He prescribed for her throat and said it would not be necessary to come again. We had intended leaving Friday noon after services—for Vitello, and proceeding thence on Saturday to Orvieto for Easter, but the Doctor said perhaps it might be wiser not to start until Saturday. She had no fever at all so I was not alarmed in the least, nor was Ellen. When however she still complained of "feeling badly" though her throat was better, and especially when she had some temperature for the first time Saturday morning, I sent again for Dr. Baldwin, who then found she had some Grip & cold extended down to her Bronchials. He has been here again today & says she has improved considerably. We do not expect now, however[,] to be able to get away from here until toward the end of the week, for I want her to be quite well again before we start.

Your Mother's illness is largely caused by her overdoing her sightseeing & shopping, in my opinion. I tried to restrain her ardor but then she insisted she was not tired and must do this and that. I am very sorry I was not firm in keeping her from doing so much.

[April 25, 1906]
Grand Hotel, Rome

Dear Constance:

24 hours ago your Mother did not seem quite so well. Her heart action was not so good—the pulse being somewhat irregular and rapid.

Our watchful Doctor, however, immediately set to work to circumvent this tendency by some change in medicine, and reported conditions better last evening and quite satisfactory this morning.

I imagine it may be May 1st before she will be sitting up in our parlor & if so it may take another week before she will be strong enough to allow traveling.[5]

The first decade of the twentieth century brought Flora tremendous personal satisfaction in her children's achievements. The years were marked by educational milestones, with Livingston's and Amasa's graduations from University School and Yale College, Constance's graduation from Hathaway Brown School and matriculation at Briarcliff College in New York, and Philip's graduation from University School. After Yale, Livingston assumed his place in the iron ore industry with the Cleveland Cliffs Iron Company, married, and started a family.

In June 1907 Amasa Stone Mather embarked on an eighteen-month world tour, during which he kept a diary and notebooks, in addition to the newsy, affectionate letters he sent his family. His thoughts were never far from home. Evident in his letters was the influence of his parents' faith as well as their philanthropy.[6]

[October 24, 1907]
Hokuto, Formosa

Dear Phid: We had a very pleasant two days in Shang-hai, which we reached by coasting steamer from Chig-Wan-Tao and where I saw a good many pleasant people, among whom President and Mrs. Thwing again . . . and mother's friend, Mr. Lewis, secretary of the Y.M.C.A. in Shang-hai. I didn't know until he told me how deeply interested mother had been in this work, and how liberally she has given towards it.

[January 25, 1908]
Calcutta

Dear Father:

I received here letters nine to seventeen, as well as nineteen, from mother, two from Phid, one from Aunty Kate, and five from you. The home news was like manna. . . .

I'm now going to take up the matters which mother spoke about, because I suppose you feel the same way.

First, as regards the observance of Sundays; I haven't perhaps been as careful as I should have been, but usually, as mother surmised, it was because something presented itself which seemed too valuable to lose (as for instance, the old rock monastery in Foochow) or else I wasn't able to arrange to be anywhere on Sunday where there was

a church service, boats and trains not being as convenient out here, as at home, but where I have been able, I have gone to church, i.e. Tokio, Peking, Hong Kong, Singapore, Hsipaw, and Calcutta.

Second, in regard to mission and Y.M.C.A. work, I've been very conscientious since leaving Japan. In Seoul and Muken, I visited missionaries and missionary hospitals. . . . at Peking several, and also saw something of Y.M.C.A work. In Shang-hai, I went all over the fine new Y.M.C.A. building with Mr. Lewis.[7]

Flora and Sam also maintained correspondence with their other children away from home, keeping them apprised of the latest news in Cleveland and on Euclid Avenue, about each other's accomplishments and exploits, and about the family. On August 5, 1908, Sam wrote Constance, a junior at Briarcliff College, about the funeral of her grandmother Elizabeth Gwinn Mather, who had died at age eighty-three.

He closed this solemn letter to Constance on a distressing note:

Dr. Cushing thinks it advisable to have a little operation performed on your Mother some time next week, at the Hospital, by Dr. Crile: and while attended by very little danger yet I know you will much rather be at home when it takes place, especially if she is to be at Lakeside, which they recommend as insuring greater quiet & care: so when the day is decided upon Livingston will come on to Lake Placid to meet you. I will wire you or Dr. Smith when to expect Liv. He will arrive probably, at 3:05 P.M. & you will leave the same evening, reaching Cleveland, the next morning at 10:45. It is still possible that this operation may be postponed: but I do not think it likely so am writing to prepare you.

In January 1908 Flora had consulted with Dr. Edward Cushing about a little brown mole on her right breast. He thought it should be removed and referred her to Dr. Crile. "A trifling matter," said Flora. "The operation was painless, so that when it was over I did a few errands before going home."[8]

In early June, Flora visited Dr. Cushing again, this time about "a little lumpiness in the breast," but he saw nothing to indicate trouble. In early August, when she saw him again, "things seemed to him so serious that he sent at once for Dr. Crile." Her breast was quite hard, and she was experiencing

stabbing pain. Drs. Cushing and Crile hoped an operation "would be a cure" and planned to use "X rays . . . after to kill any possible traces."[9]

When Flora told Sam about her meeting with Cushing and Crile, he was stunned. That day, August 5, he wrote Clara:

> Flora told me this morning that she had been to see Dr. Cushing yesterday afternoon about a pain in her breast: and that he had told her it was a tumor—had sent for Dr. Crile and that both had said an operation was immediately necessary. I have seen both of them today myself, Dr. Cushing told me if it was his own wife he would unhesitatingly have the operation performed & at once. It is cancerous and already as large as an egg. It is marvelous and unaccountable that it was not discovered by him before. I have demanded the counsel of the best man in the "U.S." on such trouble before consenting and Dr. Holsted of Johns Hopkins has been wired to.
>
> Dr. Cushing says that without an operation she cannot live more than two or three years and is liable to have great pain a little later. He says the percentage of fatality from operation is low but acknowledges that chances for *complete recovery* are not nearly so good: but says she will in any event live longer & with less pain.
>
> Cushing says Crile is the best operator in such cases in America in his judgment, or at least equal to the best. Of course I know Cushing is devoted to Flora and he is greatly distressed about it. I am going to send Livingston for Constance right after Mother's funeral, which is tomorrow afternoon at 3:30. If Holsted can be secured & the operation if it is done & I presume it must be should take place very soon—possibly Saturday—certainly by early next week.
>
> Dr. Crile operated on her last January to cut off a mole on the breast & saw nothing else. Dr. James treated her in February in N.Y. & apparently saw nothing. Dr. Cushing looked superficially at her breasts about June 1st when she complained to him of a little pain; he says he understood her to say that the "scar" pained her—but seemed to see nothing to cause alarm then. Yet now he says it is either a *very* rapidly spreading tumor else it must have been there at times of previous examinations & yet was undiscovered. I cannot understand it and am distracted.
>
> Flora did not wish me to tell you, but you must know: there is

Shoreby, the Mathers' suburban summer home, was designed and built by architect
Charles F. Schweinfurth in 1890 on the shores of Lake Erie on Lakeshore Boulevard in
Glenville (Bratenahl). Western Reserve Historical Society

always risk in a surgical operation, & especially it seems to me for
one so frail as Flora: though of course her pluck and courage count
for much. She herself told them at first that she did not believe in
operations for one of her age & I said, at once, the same thing: but
the serious & positive advice of two such men is not to be lightly dis-
regarded. Please wire whether you wish to come on. I shall write in
a day or two our decision & time selected. It will probably be some
day early next week, though it is growing a little all the time.

Sam noted that Flora was, "as might be expected of her, very cool & brave
about it," though said that she was distressed that it was not discovered
earlier.[10]

Clara wanted to come at once from The Fells, where she was sum-
mering, but Flora advised against it, saying that Sam would wire her with
progress reports.

[August 5, 1908]
Shoreby

My dear Clara:

I am sorry I did not know that Sam was to write you yesterday. Do not make your plans to come to Cleveland. I *prefer not to have you*. If we decide on an operation, it is likely to be successful—that is, the operation is almost never fatal although a cure is not always effective. We've not yet heard from a consulting doctor, but I want to send this word at once to prevent you from making plans. I am quite well & not at all nervous, only sorry to be giving other people trouble & interfering with plans.

In a letter to Clara three days later, Flora offered an explanation to her sister.

Two months ago I thought there was a little undue knotting of muscle, or perhaps better to say a little lumpiness in the breast. Dr. Cushing saw nothing to indicate trouble and said it usually first showed itself under the arm hair there.

I went to him again on Tuesday & things seemed to him so serious that he sent at once for Dr. Crile. The breast is quite hard (but movable) & I've had considerable stabbing pain. They agreed that some thing should be done at once, & as Sam wrote you, named the best person to consult. We told the doctor we were both opposed to operate on people of our age. Dr. Cushing & Dr. Crile said he hoped an operation would be a cure:—that X rays were used after to kill any possible traces, but that X rays used externally had not been found to effect cures. He said an operation would be a cure. Dr. Richardson was even more encouraging. He would not let Dr. Cushing tell him anything about the case—but made his explanation quite independently. Then he told them *his* opinion before they expressed theirs.

It has been pretty hard on Sam these last three days, but he feels quite cheered now. He has, it seems to me, said & done everything that could be done to make sure we are doing the best thing.

Livingston left last night to bring Constance home. Philip will be happier to have her here, as well as Sam.[11]

The surgery was performed on August 11. Within a week after the operation, Sam wheeled Flora out onto Lakeside Hospital's veranda so she could find relief from the August heat with cooling lake breezes. Flora was judged a "prize patient" by her doctors and nurses.

[August 15, 1908]
The Lakeside Hospital

Dear Clara:

This is now the fourth day since the operation and Flora says this morning that she feels much stronger and better than any morning yet. She had, of course that means, a good night's rest.

I feel now, that, in the usual order of events, she has escaped not only the dangers of shock, hemorrhages, and exhaustion but also the danger of pneumonia.

So unless something unforeseen occurs she should now convalesce nicely. Of course a cancer so far along as hers is liable to come again: they told us so frankly at the start: but we will not try to cross that bridge until we come to it.

Tuesday morning we took her to the etherizing rooms at 8:30. She took the ether splendidly, without fighting it as so many do. She held my hand until completely under its influence, and then they sent me away and took her into the operating room. I waited just outside, and Livingston & Grace in an adjoining room. Dr. Crile said it *might* be necessary to have a transfusion of blood from Livingston to Flora, but fortunately it was not required. I offered myself but he said the same blood was better.

The operation proper lasted an hour & 10 minutes, the sewing up half an hour. It was 5 in the afternoon before she became completely conscious again. They put a salt solution into her veins after the operation to assist resisting the shock from loss of blood.

Crile said he made this the most extensive and thorough operation he had ever accomplished to remove, so far as possible, the necessity for a future one. Cushing was present all the time, and came out at intervals to report to me.

Dr. Haydn turned up when it was about half over and remained until it was finished. He had been asked to say prayers in the Old Stone Church on the Sunday previous & so knew of it.

Our quarters here at the Hospital are quite comfortable. Flora has a large corner bedroom, with rooms off for nurse, & private bath room. I have another corner room next to hers, also with my private bath. We have 4 nurses, two for day & 2 for night shift, so that Flora is never left alone, one nurse being always in her room. The food is good & everyone most attentive.

The children come in frequently, friends inquire & her room is kept full of flowers. For the past 2 days I have been allowed to read aloud to her at intervals for say half an hour at a stretch, which she enjoys.

It has been a trying time: but it now promises well.[12]

After being released from Lakeside in mid-September, Flora convalesced at Shoreby, where she welcomed regular visits from family and friends. Sam remained devoted to her, reading aloud to her several times daily and keeping Clara apprised of her progress. In a letter to Flora written while he was at Mohonk Lake, New York, Sam wrote: "I don't think I ever quite knew what a wonderful little woman you are until your illness revealed a rare sweet patience, and an unconscious bravery and cheerfulness on top of all your other qualitites. If the dear Father will only entirely restore you to health and to a family that cannot get along without you, it seems as though we could, not be quite grateful enough."[13]

Early in November, his spirits buoyed, Sam wrote to Constance, at college, about a proposed post-Christmas family holiday: four months on the Riviera.

Do you prefer to return to school after the Christmas Holidays, or go to "Cannes" on the Riviera with your Mother, Philip and me, sailing January 21st to Genoa?

The suddenness of this proposition will doubtless surprise you: but I have been thinking for some time that it would be unwise to allow your Mother to undertake moving and settling in the new house [from Shoreby to Euclid Avenue]—until she has quite recovered her strength and health; and I think the very announcement to her that we would not consider getting into the new house until next October has already been a relief to her.

If then we are not to move into town the next best thing and in every way and in every event the best for her anyway, is to go

where she can walk and drive out of doors during the bad months of January February March and April. So after considering California and Georgia I urged the "Riviera" and she fell in with the idea with much pleasure and thinks she will like it very much. Both Drs. Cushing & Crile think favorably of it, and Dr. Cushing may possibly go over with us and see us settled. . . .

. . . Your Mother is doing fairly well, and the last grafting seems to be doing well.[14]

In early January, Clara arrived to be at Flora's side. "I hardly know what to say about Flora," she wrote to a friend. "She is coughing more and that takes her strength but she has been remarkably strong for all she has gone through. I have faith that she is going to be spared to us and shall not give her up yet. She is so brave and composed herself that she makes everyone else feel the same, but she is putting all her affairs in order and looking out for the future comfort of her family down to the smallest detail."[15]

The plan to go to the Riviera in January was abandoned. Flora underwent a second surgery and returned to Lakeside Hospital. But she was already in a weakened state before the procedure, and afterward she suffered numerous complications, among them pleurisy. On the morning of January 19, 1909, surrounded by her family, Flora Stone Mather died. She was fifty-six years old.[16]

In her illness and even her death, Flora exuded a grace and demonstrable faith. Attending physician Edward Cushing called Flora "the bravest soul I have ever known! I have watched her with wonder and admiration and affection all these hard weeks when her thoughts were always for others and her courage never broke." Similarly, her surgeon, George W. Crile, expressed his "unbounded admiration for [her] unprecedented attitude" during her illness. He said, "She had attained a degree of freedom from physical limitations of the physical world that I have never before seen. I cannot adequately express my regret at the limitations of our knowledge and power when endeavoring to preserve such a life."[17]

Fourteen years earlier, on September 22, 1895, at Shoreby, Flora Stone Mather expressed her wishes in written instructions regarding her funeral.

I wish no remarks made at my funeral & that the prayers may be entirely impersonal. I prefer that the prayers of the Episcopal burial service be used.

I would like messages sent to Mrs. Rawson, Pres. of the D.N.&
F.K.A. [Day Nursery and Free Kindergarten Association] to Dr.
Thwing, Pres. of the Women's College, & to Mrs. Tracy, Vice Pres.
of the Advisory Council that I want no formal or informal notice
taken of my death, as though I had any special *connection* with these
institutions.

It may seem to me wise to express my reasons fully in a letter to
my children; it is sufficient here to say that they are entirely suffi-
cient, & have to do with the strong feeling I have that those who
give money are often wrongly estimated. I have tried to be a faithful
steward of the means left me by my father. There are higher virtues
in humbler lives than mine; far more admirable, far more lovable.

I will be glad if it shall be suitable to my family to place my coffin
in the library, in the midst of my own people, not in the drawing-
room or hall among acquaintances, more or less friendly.[18]

Following her wishes, the funeral service was held at the Old Stone
Church. The gray casket with a simple wreath of violets stood against a
great background of flowers. The service was conducted by the Reverend
Andrew B. Meldrum, pastor of the Old Stone Church, and assisted by the
Right Reverend William A. Leonard, Episcopal Bishop of the Diocese of
Ohio, "I am the Resurrection and the Life," read Dr. Meldrum, open-
ing the Burial of Service from *The Book of Common Prayer*. No sermon
was preached or eulogy pronounced. The Old Stone Church choir sang
Tennyson's "Crossing the Bar," "Rock of Ages," and "Jesus Lover of My
Soul." The service lasted half an hour.

The mourners then processed to Lake View Cemetery. At Adelbert
College and at the College for Women, the students of the Western
Reserve University stood with bared heads, the young men waiting on
the Adelbert Campus in front of Hatch Library and the young women
beside the Memorial Arch on Euclid Avenue. An alumna of the class of
1894 wrote: "I came to Cleveland that day and stood there too because
it seemed that here, near the campus in which she showed such interest
and to which she had given so much, was the place in which to say the
last 'good-bye.'"[19]

The Legacy of Flora Stone Mather

Beyond anything under my observation, stewardship with her, was a reality. She held her trusts and her ability to do great and little things as well, from God. This was the secret of that studiousness which she gave to her benevolent work and of her desire to know, as far as she might, the recipients of her favors.
—*Hiram C. Haydn,* Flora Stone Mather: In Memoriam, 1852–1909

While her wishes were respected, there was a deep heartfelt desire among many to eulogize Flora Stone Mather for the extraordinary humanitarian and philanthropic efforts she brought to the worlds of religion, education, and social welfare. Tributes and expressions of loss and grief poured in from every quarter. Fellow patrons and benefactors as well as social workers, educators, students, and recipients of her good works celebrated her unflagging zeal and untiring efforts, her kindness and gentleness of spirit, her strength of character and loving heart, her wisdom and faith, her vision.[1]

A Goodrich House associate wrote: "Mrs. Mather was so much greater than her possessions, that the best thing she gave was the guidance of her wise brain and loving heart and the inspiration of her beautiful life. Never strong in body and with a multitude of interests she came here week after week, never too busy nor too tired to give herself to the work she so much cared for. A great love of humanity was hers." The Children's Aid Society noted, "Traces of her influence are riven into the whole composite of

this city's life and growth, so that one is led to believe that her purposeful and unselfish labors have been strong factors in determining the social attitude of this community."

A member of the College for Women Advisory Council stated, "I do not think in the history of Cleveland there has ever been a woman resembling her. I do not think we shall ever have another like her." In a most unusual accolade for the day, a *Cleveland Leader* editorial, titled "A Woman's Noble Life," eulogized, "Mrs. Mather achieved a career of which any man might well be proud." And one girlhood classmate of Flora's remarked, "She has always been to me the expression of perfect womanhood, the standard toward which to strive as far as might be."[2]

In the twenty-five years before her death, Flora Stone Mather achieved a remarkable record for philanthropy. Her will, dated January 8, 1909, and a memorandum attached on January 13, listed bequests and pledges to more than thirty educational, religious, and humanitarian enterprises in the United States and abroad.

Foremost was her desire to honor the memory of her father, Amasa Stone. In his name she gave a bequest of $75,000 to erect a chapel on the campus of Adelbert College and $15,000 for endowment toward its maintenance, to be matched with equal amounts by her sister, Clara Stone Hay. In 1907 Flora had written to Western Reserve University president Charles F. Thwing: "If acceptable to you and to the Trustees of Adelbert College Mrs. Hay and I wish to build on the campus a chapel to be called the Amasa Stone Memorial. Our father had a strong conviction of the value of Biblical instruction and of church services. He believed pure religion to be the only sure foundation for the individual or for the community life and so it seems fitting that a chapel bearing his name should be placed on the campus of the college in which he was so deeply interested."[3] On the morning of June 19, 1909, exactly five months after Flora's death, the cornerstone was laid for the Amasa Stone Memorial Chapel on the Adelbert College Campus of Western Reserve University. And two years later, on the afternoon of June 13, 1911, the Amasa Stone Memorial Chapel was dedicated, realizing the fulfillment of his daughter's belief in his religious convictions. In the large south window of the same chapel, a memorial to Flora Stone Mather was installed, given by her sister, Clara Stone Hay. Based on Corinthians 1:13—"Now abideth faith, hope and

charity, these three, but the greatest of these is charity"—it depicts the Crucifixion as the great act of charity, the Resurrection in the appearance of Christ to Mary Magdalene as hope, and the Annunciation as faith.[4]

Flora's will also listed bequests for organizations to which she had given her support throughout her lifetime. She drew upon her intimate knowledge of each one, gained through her years of involvement, and set the amounts based on present and anticipated future needs. She remembered them all: the Children's Aid Society of Cleveland, $25,000; the First Presbyterian Old Stone Church, securities to yield an annual income of $1,500; the Board of Foreign Missions of the Presbyterian Church of the United States of America, and the Board of Home Missions, each $10,000; the Presbyterian Board of Ministerial Relief for Disabled Ministers and the Widows and Orphans of Deceased Ministers, $15,000; and the Board of Missions for Freedmen of the Presbyterian Church of the United States of America, $5,000.

Her executors were instructed to continue the annual $4,000 payments to Lakeside Hospital she had been contributing toward its current expenses and maintain the $2,000 she had been contributing for the same purpose in her mother's name, or in the form of monies and securities to support an endowment that would yield the total amount of $6,000 annually.

The Young Ladies Branch of the Women's Christian Association of Cleveland received $5,000 in trust for a retreat facility and a $10,000 endowment for the benefit of the Home for Aged Women. The Cleveland Day Nursery and Kindergarten Association received annual funding of $2,400 for the expenses of administration and building maintenance of the Day Nursery at 144 Hamilton Street and for support of the kindergarten program at the Goodrich Social Settlement. With an annual budget between $12,000 and $13,000, Goodrich was anticipating relocation and the sale of its current building. Whatever its future needs, her executors were instructed to ensure the continuation of the work of the settlement.

She also gave bequests to the following educational institutions: Lake Erie College in Painesville, Ohio, $5,000; Hampton Institute of Hampton, Virginia, $5,000; and Tuskegee Institute in Tuskegee, Alabama, $1,000. And at Western Reserve University, bequests of $41,500 and $18,500 for endowments went to the College for Women and to Adelbert College, respectively.

In a memorandum, Flora Stone Mather listed pledges, both institu-

tional and individual, she wanted continued from 1909 through 1912, with specific amounts given for each year. Educational institutions named and often cited for student aid included Wooster College, Lake Erie College, Atlanta University, Berea College, and Idaho College. Among the religious institutions listed were the Old Stone Church for Communion Alms and Ladies Society, Home for Children of Missionaries, Young Women's Christian Association, International Committee of the Young Men's Christian Associations of Cleveland and Ohio. She accounted for her social welfare interests with pledges to Central Friendly Inn, Associated Charities of Cleveland, Alabama Industrial Association, Armenian Relief, Association for the Blind, Day Nursery and Kindergarten Association, and the Visiting Nurses Association. She also named numerous individual family members and others in need to receive ongoing financial support.

The fourteenth item in the Last Will and Testament of Flora S. Mather read: "I give and devise and bequeath all the rest residue and remainder of my estate, real and personal, which I may have at my decease and wherever situated, to my husband, Samuel Mather, and to my children and their heirs, equally, share and share alike." Flora named her husband and J. H Wade as executors, and her daughter, Constance, and sister, Clara, signed as witnesses.[5]

In the years that followed, Samuel Mather and his children continued Flora's commitment to the College for Women. In 1914 they erected the Flora Stone Mather Memorial Building, the main teaching and administrative unit, and the only structure that carried her name. In 1930 Samuel gave a $500,000 addition to the building. In 1913, alumnae and friends honored her with a dormitory, the Flora Stone Mather House, built on the college campus.

In 1931, the Board of Trustees of Western Reserve University prevailed upon fellow trustee Samuel Mather to grant permission for the College for Women to be renamed Flora Stone Mather College. This had been suggested many times during Flora's lifetime, but she would never allow her name given to it or any institution. When university president Robert E. Vinson announced the action of the board, he indicated that the suggestion had originated in the alumnae association. The formal announcement read that the college had been given its new name "in loving and grateful memory of one who in its early days gave needed support and who through personal service over many years helped to mold its character and ideals."[6]

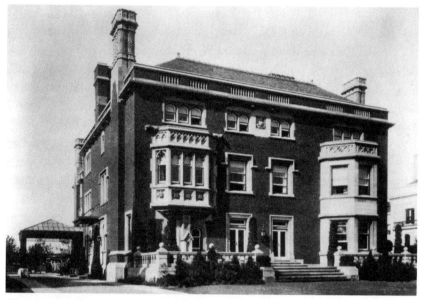

The Mathers' Cleveland manor home at 2605 Euclid Avenue was designed and built by Charles F. Schweinfurth with the full participation of Sam and Flora. Flora died in 1909 before it was completed in 1912. Western Reserve Historical Society

When President Emeritus Charles F. Thwing made the announcement, he offered the consummate tribute:

> Mrs. Mather was one of the most self-less women ever known to me. She had in a sense thrown herself outside of her selfhood. Yet she was a full, noble, and complete self. The mystery is explained somewhat by the fact that her purposes, her work, her interests, were found not in herself, but in a life beyond her own. The intellect was keen, broad, deep, and high in its thinkings and aspirations. Her intellect was devoted to the understanding of great causes. Her intellect also was just and discriminating. Her heart was a worthy companion of the intellect. It overflowed with love to all and to each, to great causes and to all personalities.[7]

The quality and character of Flora Stone Mather's efforts as a philanthropist reminded many of a ministry. Her personal convictions were demonstrated in the implementation of her good works. One saw in them a reflection of "the catholicity of her methods and her Christian desire."

This characterization by William Leonard, bishop of the Episcopal Diocese of Ohio, was illustrated in the words of a social worker who found Flora's ideals "so high, her living up to them so apparent, that unconsciously she became to a great number a guiding star. She entered into every good work with such zeal and enthusiasm that all our energies were kindled; we could not flag in the presence of that indomitable spirit." Revered at Western Reserve University, students grew "to love and be guided by the silent inspiration generated by her intense interest in our work." A student in the College for Women believed that "she left us young women a legacy that we can draw upon as long as we live. I do hope that some of us can remotely resemble her in head and heart, in persistent energy, in courage, in gentleness and all that makes up a wonderful woman."[8]

Samuel and Flora Stone Mather's four children carried on their parents' philanthropic tradition, their legacy of giving.

S. Livingston, their oldest, entered the Cleveland Cliffs Iron office to carry on the work of his uncle William Gwinn Mather. He and his wife, Grace Harman Mather, had four children: two daughters, who reached adulthood, and two sons, who did not. An active philanthropist, Livingston was a trustee of Western Reserve University, the Home for Aged Women, traditional Mather beneficiaries. He founded the S. Livingston Mather Charitable Trust to support educational, health, and welfare programs.[9]

Following his world tour of 1907–8, Amasa Mather returned to learn the iron business with his father's company, Pickands Mather. He was fascinated with all aspects of mining and, to increase his knowledge, sought out the geologists, mining captains, and men in the pits. During the early months of World War I, before entering the Third Officers' Training Camp at Camp Taylor, Kentucky, he served on the Federal Iron Ore Commission. After the war, in 1919, Amasa Stone returned to Pickands Mather and within a year was head of the iron and ore department. He and his wife, Katharine Hoyt Mather, had a daughter and a son. His promising life was cut short when early in 1920 he contracted influenza and died at age thirty-five.[10]

It then fell to Philip Richard, the youngest son, to enter his father's office. More interested in scholarship and social service than business, he gave up his studies in 1920 to work for Pickands Mather, where, sustained by family loyalty, he remained until 1937. He served as a trustee at Goodrich House and the Welfare Federation of Greater Cleveland and was a

leader in Community Fund campaigns. After he and his family moved to New York and then Boston, he was president and chair of the American Social Health Association. He and his wife, Madeleine Almy Mather, had four daughters.[11]

Constance Mather acted on behalf of educational institutions: the Advisory Council of Flora Stone Mather College, Hathaway Brown School, Miami University, and Kenyon College. Her civic interests revolved around the Family Health Association, the Cleveland Foundation, and the Phillis Wheatley Association. She married Robert Bishop, a Cleveland physician, with whom she had four sons. Educated at Western Reserve Medical School, Bishop was a leader in hospital administration as well as tuberculosis and public health reforms. He was director of Lakeside Hospital (1920–24) and worked for its consolidation with Maternity Hospital and Babies and Children's Hospital into University Hospitals, for which he then served as director from 1932 to 1947.[12]

Just as Flora was inspired by the philanthropic sphere in which she was raised, so it was for her children and their children, and so it is today for her heirs. There is a historical sense of place and loving reverence for the dwellings where the family gathered. There is a sense of family and duty implicitly understood and fulfilled in the commitment of generations through to the present day.[13]

Elizabeth "Betz" Mather McMillan, daughter of S. Livingston and Grace Harman Mather, recalled family luncheons on the Shoreby terrace, "Uncle Amasa's game hunting trophies from Africa," and living "in one of the old cottages on top of Little Mountain." She recalled how "when Uncle Philip was moving to Boston, he came around to me and said, 'You're it. I have appointed you to membership on the board at Goodrich House'" and credited this with her active and ongoing interest in Goodrich House ever since. She also served on the Advisory Council of Flora Stone Mather College.

Constance Mather Price, daughter of Philip and Madeleine Almy Mather, expressed the heirs' keen awareness of their role and responsibility: "When you are a Mather, you have a certain responsibility to maintain a good image and to continue the kinds of things that your ancestors did. I do feel that we were responsible to the community and we owed something to the community, paying back what was given to us. As an adult, I really began to realize what my responsibilities might be." During World War II, Constance worked for the American Red Cross Motor

Corps and the USO in Europe. After marriage and the arrival of children, she was involved with scouting and PTA and was a founding trustee of the Bratenahl Community Foundation. Similiarly, her sister Madeleine "Molly" Mather Anderson commented: "One thing we learned from my grandfather and through my father was the idea of service."

Madeleine "Molly" McMillan Offutt continued in the tradition of her great-grandmother: "The one that I share and feel a kindred spirit with is women's education." Molly served as the president of the board at Hathaway Brown, from which four generations of Mather daughters have graduated and where "the idea that we focus on is civic responsibility, being good citizens in the community and learning so that one can serve others." Confirming the ideals of Flora Stone Mather, Molly stated, "There is a family feeling that one's resources have been given from generation to generation and the stewardship of the family ability to help others is the sense that we continue to want to give."

Her brother, S. Sterling "Ted" McMillan III, son of S. Sterling and Elizabeth Mather McMillan, has been involved in several of the institutions that have been part of the family tradition of philanthropy. Goodrich Social Settlement, his first board of trustee activity, was where he claims to have "gained the understanding of the legacy that Flora left. She was trying to help people in the community, particularly the newcomers to integrate and find their way in America and in Cleveland. . . . Flora focused on the problems of the day. She taught every member of the family that there's joy in that." He recalls that in a bedroom at Shoreby there is an inscription on the fireplace mantel that reads, "Sleep not 'til you have considered how thou has spent ye day past. If thou has done well, thank God, if otherwise repent ye." He sees this as "the well spring that gave purpose to the pursuit of excellence in [Flora and Sam's] humanitarian mission. Together, Samuel and Flora Stone Mather took on the challenging problems, the important issues, the humanitarian needs of the day."

Noblesse Oblige

In French, *noblesse oblige* means "nobility obliges" or the "noble obligation." It implied that with wealth, power, and prestige came social responsibilities: if one was capable of doing a task to benefit another, one was obliged to do so. In the Old World noble birth carried these responsibilities. Transported to American shores and lacking a hereditary aristocracy, a new concept emerged: "civic stewardship—the notion that successful citizens owe a dual obligation of time and money to the community in which they have prospered—is a uniquely urban interpretation of the ancient ideal."[1]

Noblesse oblige distinguished the contributions of Flora Stone Mather to Cleveland's social, cultural, educational, and civic affairs. Her philanthropy, often described as a ministry, had its biblical origins in Luke 12:48: "From everyone to whom much has been given, much will be required: and from the one to whom much has been entrusted, even more will be demanded." Her active charity led to the creation of many of the city's most valuable and enduring institutions and justifies the accolade that she was the most memorable Cleveland woman of her era.

The esteem for Flora Stone Mather as a civic steward was demonstrated when the directors of one of the city's most important banks postponed their regular meeting because from the tower of the Old Stone Church, a funeral knell was ringing. When they came together the next day for their postponed meeting, one of them said to the rest: "Gentlemen, I have something to propose that I know is most unusual. I do not recall ever having heard of the directors of a corporation interrupting the regular course of their business to pass resolutions of sympathy with a member

on the death of his wife; but in this case it is Mrs. Samuel Mather, the most eminent woman in Cleveland, wife of the foremost citizen of Cleveland. I have been unable to think of any man whose death would mean such loss to Cleveland, as Mrs. Mather's death means. These are my reasons for proposing that we pass resolutions of sympathy." And those men looked at each other and said, one after another, "It is true. Not a man of us all in this city but could better be spared than Mrs. Mather."[2]

Notes

Preface and Acknowledgments

1. Sara Alpern et al., eds. *The Challenge of Feminist Biography: Writing the Lives of Modern American Women* (Urbana: Univ. of Illinois Press, 1992), 1–13.
2. Gladys Haddad, "A Tribute," in *Mather Musings: Flora Stone Mather Association Newsletter* (Fall/Winter 2005).

Prologue

1. *In Memoriam: Flora Stone Mather, 1852–1909* (Cleveland: Privately printed, 1910), 90.

1. 1818–1851

1. Biographical information about Amasa Stone was compiled from J. Gardner Bartlett, *Simon Stone Genealogy: Ancestry and Descendants of Simon Stone of Watertown, Mass., 1320–1926* (Boston: Pinkham Press, 1926), 1–50, 473–77, 620–26; Tyler Dennett, *John Hay: From Poetry to Politics* (New York: Dodd Mead and Co., 1933), 99; Dumas Malone, ed., *The Dictionary of American Biography*, vol. 9, pt. 2 (New York: Scribners, 1936), 70–71; Burton Smith Dow III, "Amasa Stone, Jr.: His Triumph and Tragedy" (master's thesis, Western Reserve University, 1956), 1–7. John Hay, ed., *Amasa Stone: Born April 27, 1818, Died May 11, 1883* (Cleveland: DeVinne Press, n.d.), published after Stone's death, includes a biographical sketch by Hay, a newspaper obituary, and several memorials to Stone by his contemporaries. See also in *Magazine of Western History* (Dec. 1885). Maurice Joblin, *Cleveland Past and Present: Its Representative Men: Comprising Biographical Sketches of Pioneer Settlers and Prominent Citizens with a History of the City* (Cleveland: Fairbanks, Benedict & Co. 1864), 301–8.
2. Biographical information about Julia Ann Gleason was compiled from Lillian May Wilson, *Genealogy of the Descendants of Thomas Gleason of Watertown Mass. 1607–1909* (Haverhill, Mass.: John Barnes White Press of the Nichols Print, 1909), 19–20, 24–25, 39, 108–9; 193; Bartlett, *Simon Stone Genealogy*, 473, 620.
3. Quoted in Dow, "Amasa Stone, Jr.," 4.

2. 1852–1865

1. Constance Mather Bishop, "My Mother—Flora Stone Mather," *Western Reserve University Bulletin* 41 (Dec. 1938): 16. Today Fifth Third Center stands as the location formerly occupied by the Hollenden Hotel.

2. Carol Poh Miller and Robert Wheeler, *Cleveland: A Concise History, 1796–1990* (Bloomington: Indiana Univ. Press, 1990), 52.

3. Dow, "Amasa Stone, Jr.," 16, 22.

4. William Ganson Rose, *Cleveland: The Making of a City* (Cleveland: World Publishing Co., 1950), 225.

5. Jan Cigliano, *Showplace of America: Cleveland's Euclid Avenue, 1850–1910* (Kent, Ohio: Kent State Univ. Press, 1991), 73–74.

6. Bishop, "My Mother," 17. The property had belonged to the Coolidge family. Susan Coolidge was born in Cleveland on January 29, 1835, and educated in private schools. She is best remembered for her books for girls, especially the series that began with *What Katy Did* (1872), in which she described a part of the wild garden on the property.

7. Ibid., 16.

8. Ibid., 16–18.

9. "Memorial Notice of the Reverend William Henry Goodrich DD," MSS, Western Reserve Historical Society (WRHS), Cleveland.

10. 1860 Census, microfilm CYW5, WRHS; *Directory of the City of Cleveland 1859–60* (Cleveland: J. H. Williston & Co.), 33–34.

11. Gertrude Bogart, "Miss Linda T. Guilford and Her Contribution to Education," in *The Education of Women in the Western Reserve* (Cleveland: Western Reserve University, 1926), 26.

12. L. T. Guilford, *The Story of a Cleveland School, from 1848 to 1881* (Cambridge, Mass.: John Wilson and Son, 1890), 84–85, 90.

13. U.S. Marshal's Office, Northern District of Ohio, Cleveland, Aug. 11, 1862, John Hay Papers, John Hay Library, Brown University, Providence, R.I. According to historian Alan Peskin (conversation, Aug. 12, 2003), there was a nine-month militia draft in Ohio beginning on July 17, 1862.

14. Rev. William H. Goodrich, "Commemorative Letter," Henry M. Colton, ed., *In Memoriam: Adelbert B. Stone* (Cambridge, Mass.: Riverside Press, 1866), 11–12.

15. Adelbert Stone to Flora Stone, Nov. 1, 1863, Jan. 14, 1865, folder 3, container 8, Samuel Mather Family Papers, WRHS.

16. David D. Van Tassel and John J. Grabowski, eds., *The Encyclopedia of Cleveland History* (Bloomington: Indiana Univ. Press, 1987), 927.

17. Dow, "Amasa Stone, Jr.," 31–34; Bishop, "My Mother,"16.

18. Colton, ed., *In Memoriam,* 55–56.

19. Dow, "Amasa Stone, Jr.," 32, 35n2. Judge James Mellon of Pittsburgh forbade one of his elder sons, James, to enlist in the Union army.

20. Guilford, *Story of a Cleveland School,* 93.

21. Adelbert Stone to Amasa Stone, June 25, 1865, folder 4, container 23, Samuel Mather Family Papers.

22. Prof. George J. Bush to Amasa Stone, June 27, 28, 1865, folder 2, container 23, Samuel Mather Family Papers.

23. Colton, ed., *In Memoriam,* 8, 21.

24. Ibid., 11–12.

3. 1865–1871

1. Guilford, *Story of a Cleveland School,* 95–96.

2. Ibid., 97.

3. Bogart, "Miss Linda T. Guilford," 28.

4. Linda Thayer Guilford, "Notes on the Cleveland Academy," Cleveland Academy, CWRU Archives, Cleveland.

5. *Annual Circular for the Seventh Year of the Cleveland Academy 1867–68,* Cleveland Academy, CWRU Archives.

6. Flora Stone to Linda Guilford, Oct. 11, 1868, folder 8, container 10, Samuel Mather Family Papers.

7. Diary of Julia Gleason Stone, June 24, 1868–Aug. 9, 1869, folder 5, container 23, Samuel Mather Family Papers.

8. Flora Stone compositions, box 1 22 MD, folder 1, CWRU Archives.

9. *Annual Circular for the Tenth Year of the Cleveland Academy 1870–71,* Cleveland Academy, CWRU Archives.

10. "The Cleveland Academy," June 24, 1871, Cleveland Academy, CWRU Archives.

11. Amasa Stone to Linda Thayer Guilford, July 1, 1871, Cleveland Academy, CWRU Archives.

4. 1871–1873

1. *In Memoriam: Flora Stone Mather,* 10.

2. Flora Stone to Samuel Mather, Sept. 22, 1880, folder 3, container 9, Samuel Mather Family Papers.

3. Jeanette E. Tuve, *Old Stone Church: In the Heart of the City since 1820* (Virginia Beach, Va.: Donning Co., 1994), 42–43.

4. Julia Raymond, *Recollections of Euclid Avenue* (Cleveland: Cleveland Interfolio Club, 1936).

5. Ibid.

6. Bishop, "My Mother," 18–19.

7. Bartlett, *Simon Stone Genealogy,* 625–26.

8. Bishop, "My Mother," 18; Dennett, *John Hay,* 96–97; Dow, "Amasa Stone, Jr.," 39–40; Patricia O'Toole, *The Five of Hearts* (New York: Clarkson Potter, 1990), 49–60.

9. Clara Stone Hay to Flora Stone, Feb. 12, 1874, folder 8, container 22, Samuel Mather Family Papers.

10. O'Toole, *Five of Hearts,* 54.

11. John Hay, *Letters of John Hay and Extracts from Diary,* vol. 2 (Washington, 1908); Mary Jo Kline (John Hay Library) confirmed birth dates in an email, Mar. 23 and 25, 2004.

12. Dow, "Amasa Stone, Jr.," 62–82.

13. Samuel Mather to Flora Stone, June 27, 1877, folder 4, container 2, Samuel Mather Family Papers.

14. Flora Stone to Samuel Mather, Aug. 12, Sept. 25, 1877, folder 3, container 9, Samuel Mather Family Papers.

15. The biographical information on Samuel Livingston Mather is from Rose, *Cleveland;* Thomas J. Holmes, "Samuel Mather, 1851–1931: Civic Leader and Philanthropist," MS 1932, WRHS; MSS 4578, William G. Mather Family Papers, WRHS; Bishop, "The Mather Family: Part 2."

16. The biographical information on Georgiana Pomeroy Woolson Mather is from Clare Benedict, ed., *Voices Out of the Past* (London: Ellis, 1930), 41–42.

17. James Fenimore Cooper to Hannah Cooper Pomeroy, Jan. 8, 1848, Autograph Collection of Katharine Livingston Mather, folder 2, container 26, Samuel Mather Family Papers.

18. The biographical information on Elizabeth Lucy Gwinn and her family is taken from folder 730, container 87, William G. Mather Family Papers. William Wyckoff, *The Developer's Frontier: The Making of the Western New York Landscape* (New Haven: Yale Univ. Press, 1988), 2–4, 9.

19. Samuel Livingston Mather to Samuel Mather, July 4, 1862, Oct. 17, 20, 1865, Aug. 9, 13, 14, 15, 27, 1866, Sept. 21, 27, Oct. 4, 18, 24, Nov. 1, 8, 25, 29, Dec. 12, 1867, Mar. 9, 30, Sept. 30, Oct. 7, 1868, folder 1, container 1, Samuel Mather Family Papers.

20. Henry R. Mather to Samuel Livingston Mather, July 16, 1869, folder 1, container 1, Samuel Mather Family Papers.

5. 1877–1881

1. Cigliano, *Showplace of America,* 231–32; Jan Cigliano, "Euclid Avenue: A Linear Neighborhood of Grandeur," paper delivered at Western Reserve Studies Symposium, 1991, Cleveland, typescript pp. 1–4, Kelvin Smith Library, CWRU.

2. Quoted in Cigliano, *Showplace of America,* 270, 378n26; *Cleveland Leader,* Jan. 7, 1859.

3. "Little Mountain: The Playground of the Victorian Elite," *Willoughby News-Herald,* Feb. 2, 1986.

4. Flora Stone to Samuel Mather, late 1879, folder 4, container 10; Samuel Mather to Flora Stone, Jan. 14, 1880, folder 4, container 2; Flora Stone to Samuel Mather, June 12, Aug. 2, 6, 1880, folder 3, container 9, all in Samuel Mather Family Papers.

5. Dow, "Amasa Stone, Jr.," 96.

6. Flora Stone to Samuel Mather, Sept. 12, 1880, folder 3, container 9, Samuel Mather Family Papers.

7. Samuel Mather to Flora Stone, Dec. 30, 1880, folder 4, container 2; Flora Stone to Samuel Mather, Dec. 31, 1880, folder 3, container 9, both in Samuel Mather Family Papers.

8. Flora Stone to Samuel Mather, Jan. 17, 1881, folder 4, container 9, Samuel Mather Family Papers.

9. Flora Stone to Samuel Mather, letters beginning Sept. 16, 1880, through July 22, 1881, folders 3–5, container 9, Samuel Mather Family Papers.

10. Flora Stone to Samuel Mather, Sept. 30, 1881, folder 6, container 9, Samuel Mather Family Papers.

11. "Wedding Presents, Flora A. Stone, October 1881," folder 6, container 11; Flora Stone to Samuel Mather, n.d., folder 5, container 10, both in Samuel Mather Family Papers.

12. Flora Stone to Samuel Mather, Oct. 2, 1881, folder 6, container 9, Samuel Mather Family Papers.

13. *Cleveland Herald,* Oct. 20, 1881.

6. 1881–1900

1. Flora Stone Mather to Elizabeth Gwinn Mather, Nov. 2, 1881, folder 8, container 10; Samuel Mather to Samuel Livingston Mather, Nov. 10, 1881, folder 3, container 2; Samuel Mather to Elizabeth Gwinn Mather, Dec. 24, 1881, folder 3, container 2, all in Samuel Mather Family Papers.

2. Julia Gleason Stone to Flora Stone Mather, Oct. 24, 1881, folder 6, container 8, Samuel Mather Family Papers.

3. Samuel Mather to Samuel Livingston Mather, Jan. 12, 1882, folder 3, container 2, Samuel Mather Family Papers.

4. In addition to her Great Lakes regional, local color writings, Woolson is credited with being the first Northern writer to treat the postwar South honestly and sympathetically. *Rodman the Keeper: Southern Sketches* (1886) contains some of her finest Southern tales that reflect an interest in regional description and character development.

5. Constance Fenimore Woolson to Katharine L. Mather, Mar. 2, 1882, folder 2, container 12, Samuel Mather Family Papers.

6. Samuel Mather to Samuel Livingston Mather, Apr. 9, 1882, folder 3, container 2, Samuel Mather Family Papers.

7. Frederick Rudolph, *The American College and University: A History* (New York: Knopf, 1962), 426–27.

8. C. H. Cramer, *Case Western Reserve: A History of the University, 1826–1976* (Boston: Little, Brown, 1976), 80–86.

9. Ibid.

10. Dow, "Amasa Stone, Jr.," 92–93.

11. Amasa Stone to John Hay, Apr. 21, 1883, Amasa Stone file, reel 11, John Hay Family Papers, John Hay Library, Brown University, Providence, R.I.

12. Julia Gleason Stone to Clara Stone Hay, Apr. 26, 1883, Amasa Stone file, reel 11, John Hay Family Papers.

13. Unidentified newspaper article, n.d., Records of Donors, container 1, MD box 1, folder 11, CWRU Archives.

14. Before setting his hand and seal to this will, dated Nov. 30, 1882, Amasa Stone wrote, "I do hereby revoke all former wills by me made and especially one made June 21st, 1879." Dow, "Amasa Stone, Jr.," 97–104; "The Last Will and Testament of Amasa Stone," Probate Court, Docket L, No. 469, Cuyahoga County Archives, Cleveland. The caveat issued by Amasa Stone requesting the revocation of a previous will dated June 21, 1879, was addressed by historian

Eric Johannesen, who maintained that in 1879, three years after the Ashtabula disaster of December 1876, Amasa Stone, consumed with despair over accusations of complicity and blame for the tragedy, unsuccessfully attempted suicide. Eric Johannesen, "Stone's Trove: The Legacy of an American Oligarch," *Timeline* (June/July 1989): 32.

15. Tuve, *Old Stone Church,* 100. John LaFarge (1835–1910) was an American artist of French ancestry. He studied in France and on his return to America specialized in colored glass. He found a Luxembourg glassmaker living in Brooklyn, and they worked together in opalescent glass. LaFarge produced at least 1,000 mosaic windows, some of the best known are at the Church of Ascension in New York and the Library of Congress in Washington, D.C. "Memorial Windows in the Sanctuary Old Stone Church," n.d., Old Stone Archives, Old Stone Church, Cleveland.

16. Bishop, "My Mother," 18.

17. Cramer, *Case Western Reserve,* 95; Hiram C. Haydn, "The Inaugural Address," Jan. 24, 1888, 14–22, CWRU Archives; Hiram C. Haydn, "What Shall We Do with Our Daughters? A Discourse," sermon delivered at the First Presbyterian Church, Cleveland, Apr. 9, 1888, CWRU Archives.

18. *In Memoriam: Flora Stone Mather,* 12.

19. Cramer, *Case Western Reserve,* 102–3; Hiram C. Haydn, *Western Reserve University: From Hudson to Cleveland, 1878–1890* (Cleveland: Western Reserve University, 1934), 109–11.

20. Bishop, "My Mother," 22; Advisory Council of Flora Stone Mather College, Western Reserve University 1888–1951, CWRU Archives; Haydn, *Western Reserve University,* 115–17.

21. *In Memoriam: Flora Stone Mather,* 115–17.

22. Mary Hover Collacott, talk delivered at Harkness Chapel, May 15, 1940, MSS. 2–3, Women's Advisory Council, CWRU Archives.

23. *In Memoriam: Flora Stone Mather,* 50–51.

24. Record Group 1, box 26, folder 207, Flora S. Mather, Rockefeller Family Archives, Rockefeller Archive Center, Sleepy Hollow, N.Y.

25. Walter Havighurst, *Vein of Iron: The Pickands Mather Story* (Cleveland: World Publishing Co., 1958), 34–35.

26. Ibid., 35; Van Tassel and Grabowski, eds., *Encyclopedia of Cleveland History,* 792–93, 225–26; David D. Van Tassel and John J. Grabowksi, eds., *The Dictionary of Cleveland Biography* (Bloomington: Indiana Univ. Press, 1996), 310; Register, Samuel Mather Family Papers.

27. Samuel Mather to Flora Stone Mather, Nov. 2, 4, 1883, folder 6, container 9; Flora Stone Mather to Samuel Mather, Nov. 4, 1883, folder 6, container 9, all in Samuel Mather Family Papers.

28. Samuel Mather to Flora Stone Mather, Aug. 1, Nov. 1, 2, 1883, Oct. 22, 1884, folder 7, container 2, Samuel Mather Family Papers.

29. Rose, *Cleveland,* 572.

30. Paul Kellogg, "Semi-Centennial of the Settlements," *Survey Graphic* (Jan. 1935), container 5, Goodrich Social Settlement Papers, WRHS.

31. Henry E. Bourne, *The First Four Decades: Goodrich House* (Cleveland:

William Feather Co., 1938), 1–23. Henry E. Bourne (1862–1946) was a founding trustee and vice president of the board. Correspondence among Bourne, Flora Stone Mather, and others are in container 5, Goodrich Social Settlement Papers.

32. *In Memoriam: Flora Stone Mather*, 122–23.

33. Van Tassel and Grabowski, eds., *Encyclopedia of Cleveland History*, 1000–1002; University Hospitals Willson Street/Cleveland City Hospital Annual Reports 1871–1895, Stanley A. Ferguson Archives, University Hospitals Archives, Cleveland; "Cleveland Club Woman," Oct. 8, 1930, typescript, box 102, folder 5, Samuel Mather Family Papers.

34. *In Memoriam: Flora Stone Mather*, 29–43, 107–15.

35. Flora Stone Mather to Samuel Mather, Aug. 5, 1892, folder 1, container 10, Samuel Mather Family Papers.

36. Flora Stone Mather to Samuel Mather, Aug. 14, 1893, folder 1, container 10, Samuel Mather Family Papers.

37. Grace Carter to Samuel Mather, Jan. 27, 1894, folder 5, container 1, Samuel Mather Family Papers; Cheryl Torsney, *Constance Fenimore Woolson: The Grief of Artistry* (Athens: Univ. of Georgia Press, 1989), 19–21.

38. Mary L. Mather to Flora Stone Mather, May 24, 1894, folder 7, container 8, Samuel Mather Family Papers.

39. S. Livingston Mather to Flora Stone Mather, July 30, 1894, folder 7, container 8, Samuel Mather Family Papers.

40. Flora Stone Mather to Linda Guilford, July 4, 1891, folder 8, container 10, Samuel Mather Family Papers.

41. *In Memoriam: Flora Stone Mather*, 11; Bishop, "My Mother," 19.

42. The original structure, designed by Charles F. Schweinfurth, was located at Hough and Giddings (East 71st St. today). Van Tassel and Grabowski, eds., *Encyclopedia of Cleveland History*, 1002.

43. Cora E. Canfield, "The Hathaway Brown School," n.d., Hathaway Brown School Archives; Virginia P. Dawson, *Learning for Life: The First Fifty Years of Hathaway Brown School 1876 to 1926* (Cleveland: Hathaway Brown School, 1996), 8, 12.

44. Alice E. Ball to Flora Stone Mather, May 31, 1891, folder 1, container 9, Samuel Mather Family Papers.

45. Flora Stone Mather was a member of the Women's Advisory Council of the College for Women from its inception in March 1888, when Western Reserve University president Hiram C. Haydn brought together well-known teachers in Cleveland and others who were keenly interested in educational matters. Among them was Linda Guilford, former principal and teacher of the Cleveland Academy, and Cora E. Canfield, who came to Cleveland in 1889 as a teacher at Hathaway Brown School and became its principal in 1902.

46. Quoted in Dawson, *Learning for Life*, 16; Ruth Crofut Needham, "Dedicated to the Future: The History of Hathaway Brown School 1876–1956," n.d., p. 10, Hathaway Brown School Archives.

47. Leslie Clark to Flora Stone Mather, July 20, 1906, folder 1, container 9; Mary Kline to Flora Stone Mather, July 26, 1906, folder 1 container 9, both in

Samuel Mather Family Papers.

48. Unidentified and undated newspaper article, Cora E. Canfield scrapbook, container F2, Hathaway Brown School Archives.

49. The college's Clark Hall and Guilford Cottage, named for Flora Stone Mather's teacher, were dedicated on the same fall day in 1892.

50. Entry for Julia A. Stone, July 24, 1900, and "Record of Death for Julia A. Stone," July 21, 1900, Necrology File 1850–1895, Cuyahoga County Archives, Cleveland.

7. 1903–1909

1. Flora Stone Mather to Elizabeth Gwinn Mather, Aug. 4, 1903, folder 8, container 10, Samuel Mather Family Papers.

2. *In Memoriam: Flora Stone Mather*, 11.

3. Dennett, *John Hay*, 440.

4. Flora Stone Mather to Constance Mather, Feb. 12, 17, 1906, folder 8, container 10; Samuel Mather to Constance Mather, Mar. 6, 1906, folder 3, container 3, both in Samuel Mather Family Papers.

5. Flora Stone Mather to Constance Mather, Feb. 12, 17, 1906, folder 8, container 10; Samuel Mather to Constance Mather, Mar. 6, 15, Apr. 15, 25, 1906, folder 3, container 3, all in Samuel Mather Family Papers.

6. These were compiled along with the letters that Amasa wrote to family members in a volume edited and privately printed by Samuel Mather in 1910, titled *Extracts from the Letters, Diary, and Note Books of Amasa Stone Mather June 1907 to December 1908.* Sam wrote an introduction to his son's book. A copy can be found in the Kelvin Smith Library, CWRU.

7. Ibid., 47, 128–29.

8. Samuel Mather to Constance Mather, Aug. 5, 1908, folder 3, container 3; Flora Stone Mather to Clara Stone Hay, Aug. 5, 1908, folder 8, container 10, both in Samuel Mather Family Papers. George Washington Crile (1894–1943) served several Cleveland hospitals, including Lakeside, where he was chief of surgery. He taught at Western Reserve Medical School from 1900 to 1943 and is reputed to have performed the first successful human blood transfusion in 1906. He is credited also with perfecting operations for goiter and thyroid disease as well as known for studying intelligence and personality, theorizing that the human organism is an electrochemical mechanism. He was a founding member and the second president of the American College of Surgeons. Van Tassel and Grabowski, eds., *Dictionary of Cleveland Biography*, 109–10.

9. Samuel Mather to Clara Stone Hay, Aug. 5, 1908, folder 3, container 3, Samuel Mather Family Papers.

10. Samuel Mather to Clara Stone Hay, Aug. 5, 1908, folder 3, container 3, Samuel Mather Family Papers.

11. Flora Stone Mather to Clara Stone Hay, Aug. 5, 1908, folder 8, container 10; Flora Stone Mather to Clara Stone Hay, Aug. 8, 1908, folder 8, container 10, both in Samuel Mather Family Papers.

12. Samuel Mather to Clara Stone Hay, Aug. 15, 1908, folder 3, container

3, Samuel Mather Family Papers.

13. Samuel Mather to Flora Stone Mather, n.d., 1908, folder 9, container 2, Samuel Mather Family Papers.

14. Samuel Mather to Constance Mather, Nov. 5, 1908, folder 3, container 3, Samuel Mather Family Papers.

15. Clara Stone Hay ALS to Mary [Mrs. J. B. Savage], Jan. 10, 1909, MSS. vf H, WRHS.

16. *In Memoriam: Flora Stone Mather,* 137.

17. Ibid., 120, 121.

18. Dated instructions by Flora Stone Mather, Sept. 22, 1895, folder 8, container 10, Samuel Mather Family Papers.

19. *In Memoriam: Flora Stone Mather,* 16–17; MS., Mary Hover Collacott '94, folder 1, container 12, Samuel Mather Family Papers.

8. The Legacy of Flora Stone Mather

1. In 1910 Samuel Mather oversaw the publication of two books. *In Memoriam: Flora Stone Mather, 1852–1909* marked the first anniversary of Flora's death. It included a biographical sketch; details of the funeral service; tributes from representatives of religious, educational, and philanthropic organizations; extracts from personal letters; and editorials. The other, *Extracts from the Letters, Diary, and Note Books of Amasa Stone Mather, June 1907 to December 1908,* was published in two illustrated volumes and dedicated by its author, Amasa Stone, "To the Memory of My Mother." A copy can be found in the Kelvin Smith Library, CWRU.

2. *In Memoriam: Flora Stone Mather,* 98, 62, 93, 135–36, 125.

3. Flora Stone Mather to Charles F. Thwing, June 10, 1907, 1 DB6, Thwing Office Files, folder 2, box 3, Amasa Stone Chapel, Records of the CWRU Buildings, CWRU Archives.

4. "The Amasa Stone Memorial Chapel," *Western Reserve University Bulletin* 14.6 (Nov. 1911): 100–101; "Service of Dedication of the Amasa Stone Memorial Chapel Tuesday 13 June 1911," Amasa Stone Chapel, Records of the CWRU Buildings, CWRU Archives.

5. "The Last Will and Testament of Flora S. Mather," Jan. 8, 13, 1909, folder 7, container 11, Samuel Mather Family Papers.

6. "Women's College Given New Name," *Cleveland Plain Dealer,* Feb. 22, 1931, Flora Stone Mather, folder 7 PI, CWRU Archives.

7. Quoted in "Mrs. Moffett's Speech," Apr. 6, 1952, typescript, Flora Stone Mather, folder 7 PD, CWRU Archives.

8. William Andrew Leonard, bishop of the Ohio Episcopal Diocese; *In Memoriam: Flora Stone Mather,* 139; Mrs. N.D.M., ibid., 126; Mrs. R.W.B., ibid., 119.

9. Van Tassel and Grabowski, eds., *Dictionary of Cleveland Biography,* 310.

10. Havighurst, *Vein of Iron,* 136–38.

11. Ibid., 140; Philip Richard Mather obituary, *Cleveland Plain Dealer,* Sept. 21, 1973, Stanley A. Ferguson Archives.

12. Van Tassel and Grabowski, eds., *Dictionary of Cleveland Biography,*

43–44; Kitty Makley, *Mather Mansion Revisited: The Man, His City, His House,* Sept. 1977, pamplet p. 19, Special Collections, Cleveland State University.

13. Following are edited extracts from interviews taken by the author, and in her possession, from three Mather family video documentaries she produced: *Samuel Mather: Vision, Leadership, Generosity* (1994), *Samuel and Flora Stone Mather: Partners in Philanthropy* (1995), and *Flora Stone Mather: A Legacy of Stewardship* (1998). Copies available in Special Collections, Kelvin Smith Library, CWRU.

Epilogue

1. Kathleen D. McCarthy, *Noblesse Oblige: Charity and Cultural Philanthropy in Chicago, 1849–1929* (Chicago: Univ. of Chicago Press, 1982), ix.

2. *In Memoriam: Flora Stone Mather,* 51–52.

Bibliography

Archives and Repositories

Case Western Reserve University Archives, Cleveland, Ohio
Cuyahoga County Archives, Cleveland, Ohio
Hathaway Brown School Archives, Cleveland, Ohio
John Hay Library, Brown University, Providence, R.I.
Library of Congress, Washington, D.C.
Rockefeller Archive Center, Sleepy Hollow, N.Y.
Stanley A. Ferguson Archives, University Hospitals Archives, Cleveland, Ohio
Western Reserve Historical Society, Cleveland, Ohio

Unpublished Manuscripts

Bishop, Constance Mather. "The Mather Family: Part 2: The Western Reserve Pioneers." MS Interfolio Paper.
Dow, Burton Smith, III. "Amasa Stone, Jr.: His Triumph and Tragedy." Master's thesis. Western Reserve University, 1956.
Haddad, Gladys. "Social Roles and Advanced Education for Women in Nineteenth-Century America: A Study of Three Western Reserve Institutions." Ph.D. diss. Case Western Reserve University, 1980.
Holmes, Thomas J. "Samuel Mather 1851–1931: Civic Leader and Philanthropist." Western Reserve Historical Society, 1932.

Published Sources

Alpern, Sara, et al., eds. *The Challenge of Feminist Biography: Writing the Lives of Modern American Women.* Urbana: University of Illinois Press, 1992.
Bartlett, J. Gardner. *Simon Stone Genealogy: Ancestry and Descendants of Simon Stone of Watertown, Mass., 1320–1926.* Boston: Pinkham Press, 1926.
Benedict, Clare, ed. *The Benedicts Abroad.* London: Ellis, 1930.
———. *Voices Out of the Past.* London: Ellis, 1930.
Bishop, Constance Mather. "My Mother—Flora Stone Mather." *Western Reserve University Bulletin* 41 (December 1938).

Bogart, Gertrude. "Miss Linda T. Guilford and Her Contribution to Education." In *The Education of Women in the Western Reserve*. Cleveland: Western Reserve University, 1926.

Bourne, Henry E. *The First Four Decades: Goodrich House*. Cleveland: William Feather Co., 1938.

Cigliano, Jan. *Showplace of America: Cleveland's Euclid Avenue, 1850–1910*. Kent, Ohio: Kent State University Press, 1991.

Colton, Henry M., ed. *In Memoriam: Adelbert B. Stone*. Cambridge, Mass.: Riverside Press, 1866.

Cramer, C. H. *Case Western Reserve: A History of the University, 1826–1976*. Boston: Little, Brown, 1976.

Dawson, Virginia P. *Learning for Life: The First Fifty Years of Hathaway Brown School 1876 to 1926*. Cleveland: Hathaway Brown School, 1996.

Dennett, Tyler. *John Hay: From Poetry to Politics*. New York: Dodd Mead and Co., 1933.

de Tocqueville, Alexis. *Democracy in America*. Ed. J. P. Mayer. New York: Anchor Books, 1969.

Earnest, Ernest. *The American Eve in Fact and Fiction, 1775–1914*. Urbana: University of Illinois Press, 1975.

Extracts from the Letters, Diary, and Note Books of Amasa Stone Mather, June 1907 to December 1908. Cleveland: Privately printed, 1910.

Guilford, L. T. *The Story of a Cleveland School, from 1848 to 1881*. Cambridge, Mass.: John Wilson and Son, 1890.

Haddad, Gladys. "A Tribute." *Mather Musings: Flora Stone Mather Association Newsletter* (Fall/Winter 2005).

———. *Flora Stone Mather: A Legacy of Stewardship*. Documentary film. 1998.

———. *Samuel and Flora Stone Mather: Partners in Philanthropy*. Documentary film. 1995.

———. *Samuel Mather: Vision, Leadership, Generosity*. Documentary film. 1994.

Havighurst, Walter. *Vein of Iron: The Pickands Mather Story*. Cleveland: World Publishing Co., 1958.

Hay, John, ed. *Amasa Stone: Born April 27, 1818, Died May 11, 1883*. Cleveland: DeVinne Press, n.d.

———. *Letters of John Hay and Extracts from Diary*. Washington, D.C., 1908.

Haydn, Hiram C. *Western Reserve University: From Hudson to Cleveland: 1878–1890*. Cleveland: Western Reserve University, 1934.

In Memoriam: Flora Stone Mather, 1852–1909. Cleveland: Privately printed, 1910.

Joblin, Maurice. *Cleveland Past and Present: Its Representative Men: Comprising Biographical Sketches of Pioneer Settlers and Prominent Citizens with a History of the City*. Cleveland: Fairbanks, Benedict & Co., 1864.

Johannesen, Eric. *Cleveland Architecture 1876–1976*. Cleveland, Ohio: Western Reserve Historical Society, 1979.

———. "Stone's Trove: The Legacy of an American Oligarch." *Timeline* (June/July 1989).

Malone, Dumas, ed. *The Dictionary of American Biography*. New York: Scribners, 1936.

Martineau, Harriet. *Society in America*. 3 vols. London: Saunders and Otley, 1837.

McCarthy, Kathleen D. *Noblesse Oblige: Charity and Cultural Philanthropy in Chicago, 1849-1929*. Chicago, University of Chicago Press, 1982.

Miller, Carol Poh, and Robert Wheeler. *Cleveland: A Concise History, 1796–1990*. Bloomington: Indiana University Press, 1990.

O'Toole, Patricia. *The Five of Hearts*. New York: Clarkson Potter, 1990.

Potter, David. "American Women and the American Character." In *American Character and Cultures: Some Twentieth-Century Perspectives*. Ed. John Hague. Deland, Fla:. Everett Edwards Press, 1964.

Rose, William Ganson. *Cleveland: The Making of a City*. 1950. Kent, Ohio: Kent State University Press, 1990.

Smith, Page. *Daughters of the Promised Land: Women in American History*. Boston: Little, Brown, 1970.

Torsney, Cheryl. *Constance Fenimore Woolson: The Grief of Artistry*. Athens: University of Georgia Press, 1989.

Tuve, Jeannette E. *Old Stone Church: In the Heart of the City since 1820*. Virginia Beach, Va.: Donning Co., 1994.

Van Tassel, David D., and John J. Grabowski, eds. *The Dictionary of Cleveland Biography*. Bloomington: Indiana University Press, 1996.

———. *The Encyclopedia of Cleveland History*. Bloomington: Indiana University Press: 1987.

Wilson, Lillian May. *Genealogy of the Descendants of Thomas Gleason of Watertown Mass. 1607–1909*. Haverhill, Mass.: John Barnes White Press, 1909.

Wyckoff, William, *The Developer's Frontier: The Making of the Western New York Landscape*. New Haven: Yale University Press, 1988.

Index